WATERCOLOUR
Planning & Painting

ALAN OLIVER

SEARCH PRESS

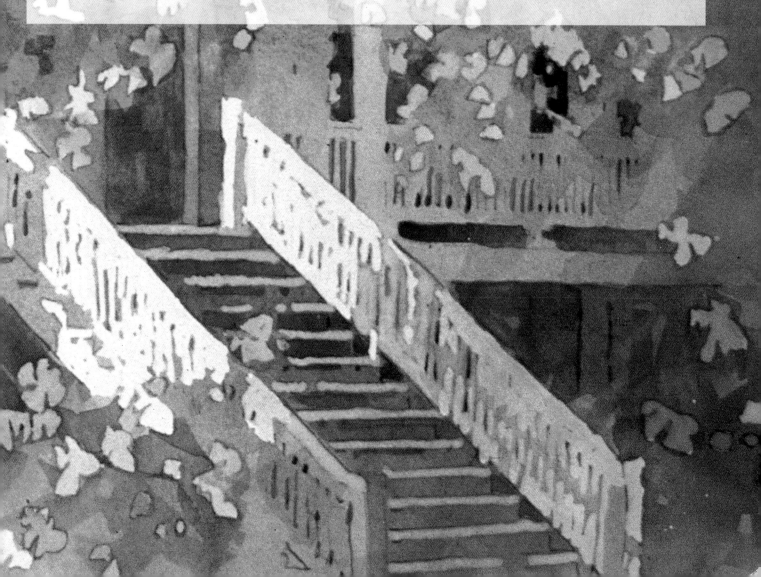

A QUARTO BOOK

First published in Great Britain in paperback 2002 by
Search Press Ltd
Wellwood
North Farm Road
Tunbridge Wells
Kent TN2 3DR

Previously published in Great Britain in hardback entitled
Perfect Watercolour

Copyright © 1998 Quarto Publishing plc

ISBN 1 903975 53 0

This book was designed and produced by

Quarto Publishing plc
The Old Brewery
6, Blundell Street
London N7 9BH

Senior editors Kate Kirby, Anna Watson
Text editors Angie Gair, Lyn Bresler
Senior art editor Penny Cobb
Designer Caroline Hill
Photographer Chas Wilder
Picture researcher Miriam Hyman
Editorial Director Pippa Rubinstein
Art director Moira Clinch

Typeset in Great Britain by Central Southern Typesetters, Eastbourne
Manufactured in Singapore by Pica Colour Separation Overseas (Pte) Ltd
Printed in Singapore by Star Standard Industries (Pte) Ltd

Page 1: 'Afternoon Practice' by Henry W. Dixon
Pages 2–3: 'Sunburst' by Judi Betts

Preface

I was a teenager when I first began to paint in watercolours. Back then, the railway companies commissioned watercolour paintings which were then made into framed prints to decorate the carriages. These little paintings made my journey to college more enjoyable, and also inspired me to take up watercolour painting. My first attempts, of course, were disastrous. I had plenty of enthusiasm but little skill, and still less patience. In my haste I plunged in too quickly; but the more I tried to correct my mistakes, the worse things got, and the results were muddy colours and tired, overworked pictures. I longed to achieve the freshness and luminosity of those little watercolours on the train.

Eventually, experience taught me that mistakes in watercolour are almost impossible to remove or paint over because the colours are transparent and some of them leave a stain on the paper when you try to wash them off. I had to try to devise a means of getting it right first time and not making mistakes. So I began to study the work of the masters of the medium: John Sell Cotman (1782–1842), Winslow Homer (1836–1910) and, the greatest of them all, Joseph Mallord William Turner (1775–1851). Their watercolour technique involved building up the image in successive layers, each layer becoming darker, more detailed and more distinct as the painting reached completion.

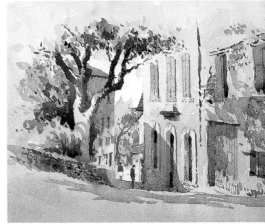

"French Street Scene" by Alan Oliver

I realised that if I could analyse a subject in terms of simple areas of light, dark and middle value, I was halfway there. By making a tonal sketch in soft pencil, I had a 'blueprint' which I could follow in my painting. Thus I knew where to start and in what order to build up layers of colour. At last my paintings took on something of the clean transparency I had seen in other artists' work.

The tonal layering technique helped me to paint better pictures. I hope that it will help you, too, and that is my reason for writing this book.

A deep-welled paint pallette

A preparatory tonal sketch

Alan Oliver

Contents

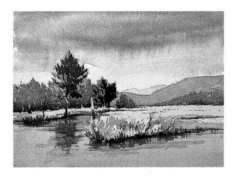
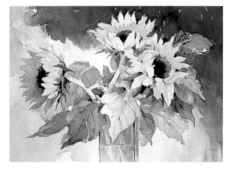

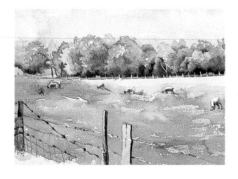
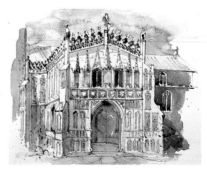

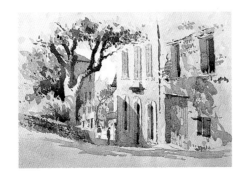
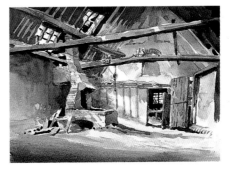

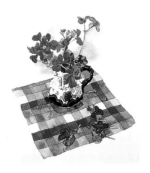

Chapter Three APPROACHES TO PAINTING 108

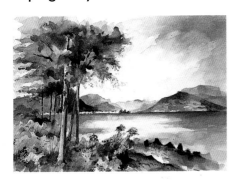
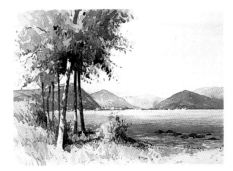

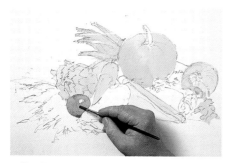

Blocking in lightest values on dry paper

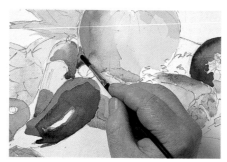

Applying the middle values

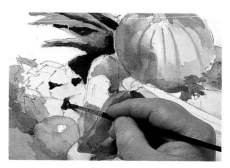

Successive layering of the dark values

Introduction

Painting with watercolours is one of the most exciting and rewarding creative processes. People are attracted to watercolour because it is such an expressive medium, and because they enjoy the thrill of learning to control its fluid, effervescent nature. The equipment required is relatively simple, too; with just one brush, a couple of colours and a sheet of paper, it is possible to produce breathtaking effects with apparent ease.

The one disadvantage with watercolour is that the paint doesn't sit on the surface but sinks readily into the paper's fibres and stains them. Once a stroke of colour is applied to the paper, there is little scope for removing it or making corrections and amendments.

Good planning is the key to successful watercolour paintings. As beginners, our enthusiasm – and impatience for results – make us anxious to get the paint on the paper and then decide what to do with it afterwards. The paint is pushed and prodded around, hasty alterations are made, and

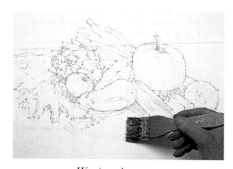

Wetting the paper

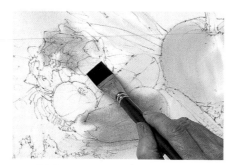

Lightest values applied wet in wet

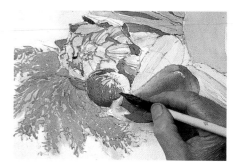

Applying the middle values

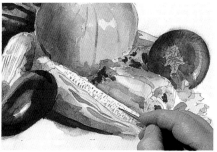

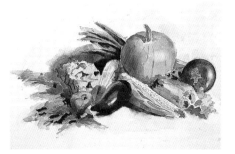

Adding detail

Lifting out highlights

The finished painting

inevitably the freshness and sparkle of the colours are lost. Such problems can be avoided by planning your paintings carefully in advance so that you can tackle them with confident ease.

My aim in writing this book is to show you, step by step, how to plan your watercolour paintings and approach them in a simple, logical way. It is a technique I call 'tonal layering', which involves analysing the lights, mid-tones and darks in your subject and then translating these onto paper by building up successive layers of colour. The lightest layer is applied first, then the second layer is brushed on over the first, followed by the third, and so on, with the darkest values applied last.

These pages show how two artists have approached the same subject in different ways. The sequence above demonstrates the 'direct' technique, in which the colours are applied to dry paper. Brushstrokes and washes are built up in layers, each layer being allowed to dry before the next is applied. In the sequence below the artist begins with the 'wet in wet' technique, in which colours are applied to damp paper, yielding softly blended, hazy colours that flow into one another. The methods may be different, but in both cases the results have a freshness only possible because the artists have planned their approach carefully in advance.

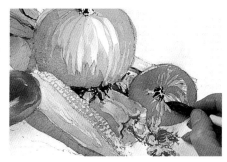

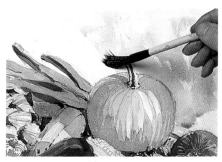

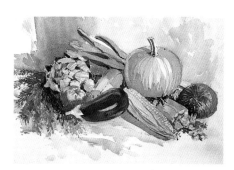

Adding detail

Strengthening the background

The finished painting

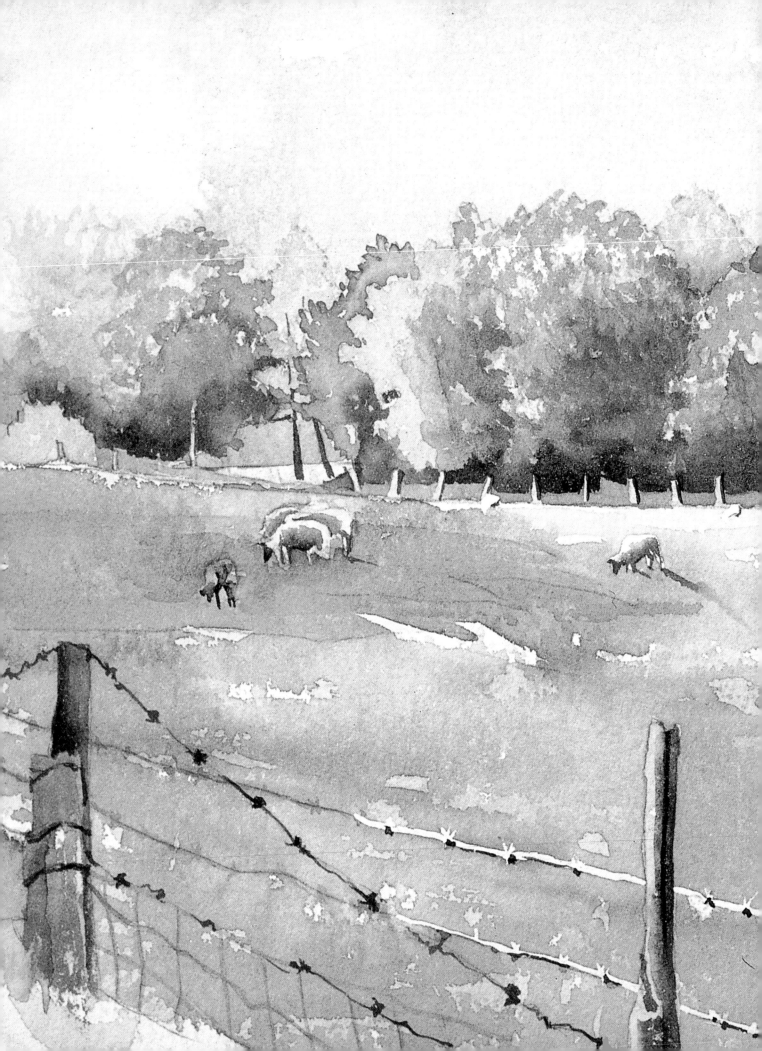

Getting Started

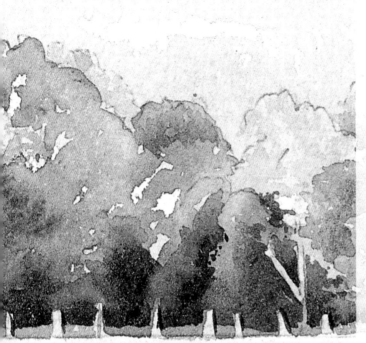

You are about to embark on one of the most fascinating and exciting pastimes of all. Watercolour painting will open up a whole new world for you; a world full of light and colour. In the process you will find yourself not just looking, but really seeing and observing things you had never noticed before, and you will be discovering new aspects about yourself in the process. Life for you will never be quite the same again. Enjoy it.

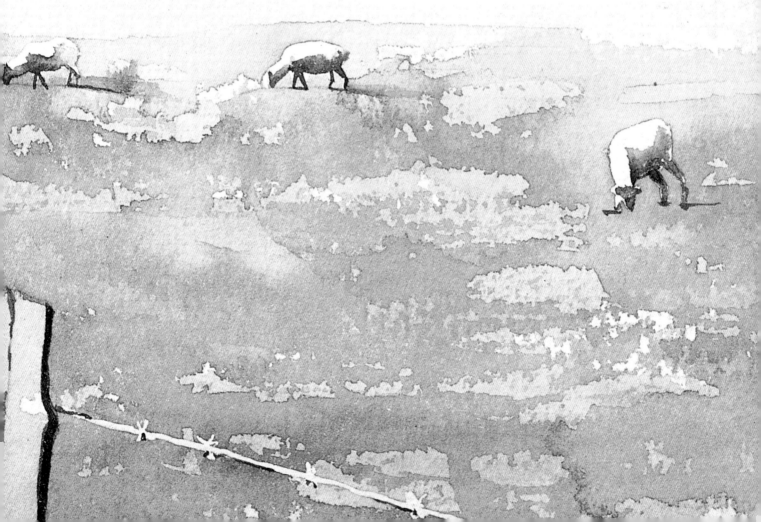

Materials and Equipment

Buying new tools and equipment for painting can be exciting, but it is all too easy to waste money on expensive items that you don't really need. It is best to start with the basic essentials, at least to begin with, and then add to them as you gain more experience. You will be able to produce excellent paintings with just a few key items. This section outlines the tools and equipment you will need to get you started.

W HEN BUYING BRUSHES, paints and papers for watercolour painting, my advice is to go for the best you can afford. You will get far better results right from the start and this will increase your confidence, even if you are a complete novice.

Paints
Watercolour paints consist of finely ground pigments bound with gum arabic and mixed with glycerine. They are available in tubes of moist colour and in small blocks, called 'pans' or 'half-pans', of semi-moist colour. In general I would recommend

tube colours as they are easier to pick up with the brush. They can be left to dry on the palette after a painting session; simply moisten them with a damp brush to use again. Tube colour comes in two grades – artists' and students'. The artists' grade paints are more expensive but they contain finer quality pigments so the colours are richer and more transparent, and the paints stay moist for longer.

Pans of colour can be bought individually as well as in special paintboxes with slots to hold the pans in place and a lid that opens out to form a convenient mixing palette. They are economical and convenient for quick sketches and paintings outdoors. However, they tend to need scrubbing at to loosen the paint initially.

As well as being sold individually, tubes and pans of watercolour can be bought in sets and boxes together with a brush or two and an integral mixing palette. These provide a convenient basic palette of colours and are easily portable for outdoor work.

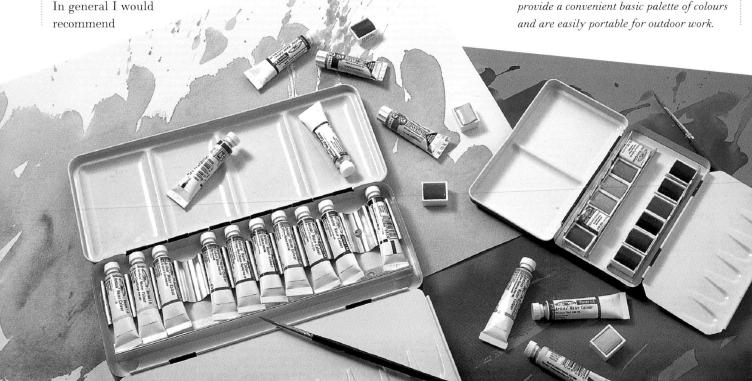

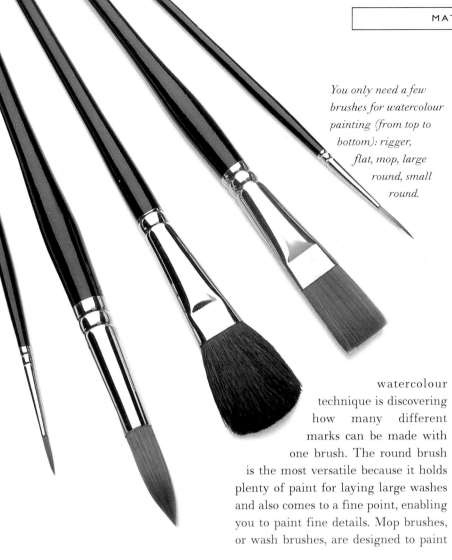

You only need a few brushes for watercolour painting (from top to bottom): rigger, flat, mop, large round, small round.

watercolour technique is discovering how many different marks can be made with one brush. The round brush is the most versatile because it holds plenty of paint for laying large washes and also comes to a fine point, enabling you to paint fine details. Mop brushes, or wash brushes, are designed to paint large areas quickly. Wash brushes are wide and flat, while mops have large round heads.

The square-ended flat brush is used for making broad, straightedged strokes.

The rigger brush has extra long, flexible hairs and is used for painting very delicate lines. These latter two are speciality brushes, worth experimenting with, but only when you feel ready to add to your basic equipment.

Brushes are graded according to size, ranging from as small as 0000 to as large as a no. 24 wash brush. The size is printed on the brush handle. Brush sizes are not standardised, so a no. 5 brush in one manufacturer's range will not necessarily be the same size as a no. 5 in another.

You will need at least two round brushes initially – say, a no. 2, 3 or 4 and a no. 12, 14 or 16. If you like working on a large scale you may also need a mop or wash brush for applying broad washes of colour.

Brushes

Your brushes are probably the most important items in your painting kit, so buy the best you can afford. A few really good-quality brushes will last longer and give you far better results than a whole fistful of cheap ones. Pure sable brushes are the best, but they are expensive. An excellent, cheaper alternative are sable blends – sable mixed with synthetic hairs. Like sables, they hold their shape well, are springy and resilient and a pleasure to use. The cheapest brushes are made of synthetic fibres. While they are good value, their drawback is that they do not hold as much water as natural-hair brushes and so tend to dry up in mid wash on occasions, which can be annoying.

Brush shapes and sizes Brushes come in various shapes, each creating a different brushstroke. It would be impractical, however, to switch brushes for each brushstroke, and part of learning

CHOOSING A BRUSH

The heads of new brushes are brought to a fine point and coated with starch size to protect them in transit. Always try out a brush before you buy it. Dip the brush in water to wash out the starch size (a good art supply shop will always have a pot of water available for this purpose). Flick the brush once to test that the hairs come to a good point. If they do not, reject the brush and try another.

Having purchased a good brush it makes sense to look after it. Rinse it out thoroughly after use, flick out the excess water and then reshape it, either by pulling it between your lips or by gently drawing it over the palm of your hand, moulding the hairs to a point. Then stand it, hairs uppermost, in a jar or lay it flat. If the hairs are allowed to dry out bent the brush will be ruined.

Stretching paper

It is always better to work on a paper surface that is flat and firm. When an area of paper is wetted it expands, forming hills and hollows. Thin paper is more prone to this effect; stretching is not usually necessary with heavier papers. The procedure is shown below.

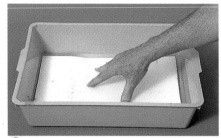

1 Cut the paper to the desired size, allowing an extra 2.5cm (1in) overlap. Immerse the paper in a dish of water and leave for about five minutes to allow the fibres to expand.

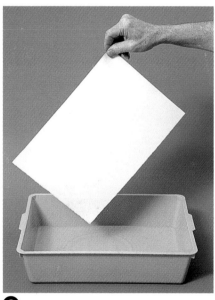

2 Hold the paper up by one corner to allow the excess water to run off. When the paper stops dripping, lay it on the board and leave it to rest for another couple of minutes.

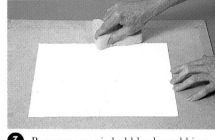

3 Remove any air bubbles by rubbing gently outwards from the centre with the back of your hand. Dry the outer edges of the paper with a sponge, ready to stick gummed paper tape over them.

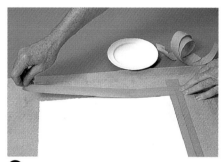

4 Cut the strips of the tape slightly longer than the edges of the paper and dampen them. Stick the strips around the outer edges of the paper, half their width on the board, half on the paper. Leave to dry naturally.

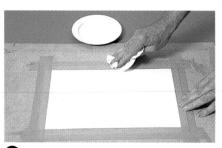

5 As the paper dries it shrinks as taut as a drum. When you wet it with your colour washes it will stay perfectly flat and be a delight to work on.

Papers

Good-quality watercolour paper is essential. Ordinary cartridge paper is fine for drawing but unsuitable for watercolour painting as it is too smooth and too thin. Watercolour paper is available in single sheets and in pads and blocks. It can be either handmade or machinemade and this difference is reflected in the price. The best quality handmade paper is made from cotton rag instead of woodpulp. Handmade papers are generally recognisable by their irregular surface and ragged ('deckle') edges. They also bear the manufacturer's watermark in one corner.

Mould-made papers are the next best thing to handmade, and are more affordable. Machine-made papers are the cheapest, but some have a rather mechanical surface grain.

Texture It is important to choose the right kind of paper, as its surface texture influences the way the watercolour washes behave. The surface texture of paper is known as its 'tooth'. There are three kinds of surface.

Hot-pressed (HP) is smooth, with no 'tooth'. It is suitable for finely detailed work, but not for heavy washes as the surface tends to buckle and the pigment settles unevenly.

Cold-pressed (otherwise known as 'Not', meaning not not-pressed) has a semi-rough surface equally good for vigorous washes and fine brush detail. This is the most popular type and is ideal for less experienced painters.

Rough paper has a pronounced tooth which breaks up the edges of a wash and produces interesting textures.

Weight The weight (or thickness) of paper is measured in grammes per square metre (gsm). The equivalent imperial measure is pounds per ream (480 sheets). The lightest watercolour paper is 150gsm (72lb) while a middleweight paper is 300gsm (140lb). The heaviest paper weighs 640gsm (300lb). The middleweight paper is fine for

general use, providing it is stretched to prevent buckling (see opposite page).

Treat the surface of your water-colour paper with care as it is easily damaged. An accidental, unseen scratch or a greasy finger mark will suddenly appear when a wash of colour is applied and can ruin a perfectly good painting.

Palettes

Watercolour palettes come in a range of shapes and sizes, and are made of either ceramic, enamelled metal or plastic. Most are divided into several recesses or wells, allowing several colours to be laid out separately and mixed with the required amount of water. Ordinary cups, bowls, plates, saucers and yoghurt pots – in all cases white and non-porous – can be used as watercolour palettes.

Accessories

You will also need a container for water. Dirty water will muddy your colours, so change the water often. Some artists use two water jars – one for rinsing out brushes and the other for clean water for mixing colours. You can buy collapsible plastic containers with a handle for working outdoors, or you could simply cut the top off a plastic soft drinks bottle.

A small natural sponge is useful for soaking up excess water or lightening an area. Tissue paper or rags can also be used for this purpose.

Use a well-sharpened, medium-grade pencil such as a 2B for drawing on watercolour paper, and a kneaded putty eraser that won't leave smudges.

Last but not least, you will need a sketchbook for noting down anything interesting you see and for making tonal sketches and trying out compositions. Look for an A4 size hardbound book with good-quality, fairly smooth paper. Soft pencils – 3B or 4B – are recommended for your rough sketches. They will give you a range of tones from black to light grey, depending on the amount of pressure you apply to the paper.

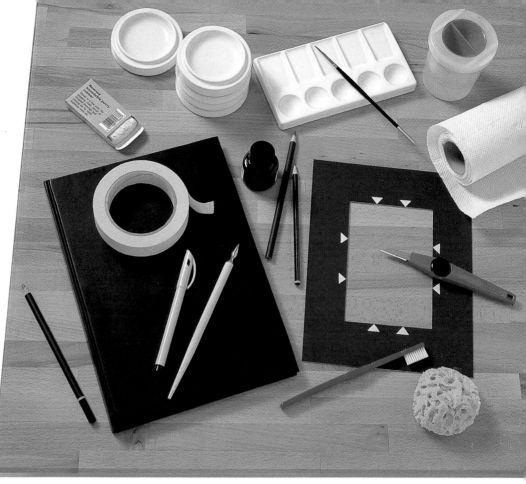

Some of the additional items you may need for watercolour painting. Clockwise from top left: mixing dishes; deep-welled palette; water pot; paper towels; viewfinder; craft knife; sponge; toothbrush; pens and pencils; drawing ink; masking tape; sketchbook; putty eraser.

BOARDS AND EASELS

You will need a lightweight wooden board to attach the paper to. Laminated boards are not suitable because the sticky paper tape used in stretching paper does not adhere to it.

An easel is not essential for indoor painting as you can simply prop your board up on a pile of books to an angle of about 15 degrees. Outdoor painting, however, will be much more comfortable with a lightweight sketching easel.

Basic Techniques

There are perhaps half a dozen techniques which form the foundation of all watercolour painting, and an understanding of them will give you the confidence to go on and exploit the many possibilities of this versatile medium. You can have a lot of fun making brushstrokes and laying smooth washes, to get the feel of the paint and what it will do on the paper.

THE AIM OF this section is to give you a grasp of some good basic watercolour techniques and, hopefully, to awaken your curiosity about all the possibilities that exist beyond them.

Laying washes

The first basic requirement of water-colour painting is learning how to lay washes smoothly and with ease. Washes are best applied quickly and in one go, so mix more paint than you think you will need and apply it with a large, well-loaded brush. Keep your wrist supple and work quickly and con-fidently so that the brushstrokes flow into each other. Once a wash is applied, leave it to dry undisturbed.

Laying a flat wash

The purpose of a flat wash is to cover large areas that cannot be done with one brushstroke. To achieve a smooth, even tone with no unwanted marks or lines, you should work on stretched paper. Dampen it with clean water using a sponge or a large wash brush. The dampness of the paper will help to spread the colour evenly.

1 Squeeze a small amount of paint into a wash compartment in your palette, or into a deep saucer or bowl, and dilute it with water. The paint should be fluid, but quite strong, to compensate for the fact that it will dry much lighter on the paper. Make sure you mix plenty of paint; if you have to stop in the middle of a wash to mix more paint you will have lost it and will have to start again.

2 Tilt the board at a slight angle to allow the wash to flow down gradually; if laid flat the paint could creep backwards, staining the wash. With a well-loaded brush, lay a band of colour across the top of the paper. Refill the brush. Repeat in the opposite direction, picking up the bead of colour which will have formed at the base of the first stroke.

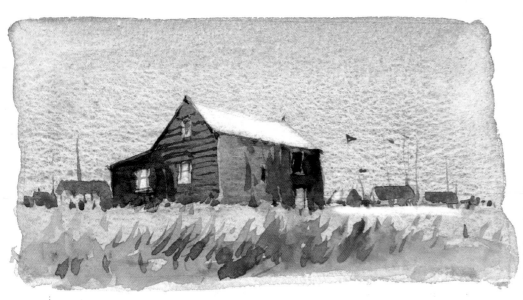

Flat washes were used for this colour sketch. When dry, colour was washed off in places to suggest light reflecting off the rooftops and windows.

3 Working backwards and forwards, continue down the paper but do not touch the wet brush onto your completed strokes no matter what, as this will disturb the wash and could cause a stain as the paint dries. The colour will diffuse and spread and gravity will help the brushstrokes to merge naturally. With practice you will come to know the delicate balance of paint and water required to create a smooth wash of colour.

4 After the last stroke squeeze the remaining moisture from the brush and use it to soak up any surplus liquid at the bottom edge. The wash should be transparent and even in colour, with no streaks or marks. If it is not, have another go. The secret is always to keep your brush full of dripping wet colour.

5 Allow the paper to dry naturally, in the same tilted position. If it is moved the colour could run back up the paper.

Laying a gradated wash

A gradated wash starts with strong colour at the top, gradually lightening towards the bottom as more water is added to the paint. Such washes are often used in creating the illusion of space and recession when painting skies, which appear strongest in colour directly overhead and gradually pale towards the horizon.

1 Start as for a flat wash, laying a band of full-strength colour across the top of the paper. Quickly dip the brush into clean water and run it under the first stroke, picking up the paint which has run down to the base of the first stroke.

2 Continue down the paper, adding bands of increasingly diluted paint. The bottom band will be very pale indeed, almost clear water. Leave the paper to dry before painting your next layer.

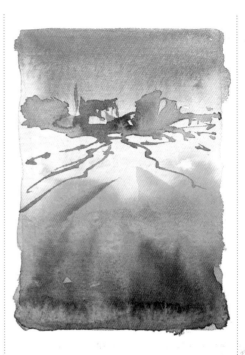

Here, gradated and variegated washes were allowed to dry and then the landscape details overlaid with sharper, crisper strokes.

Laying a variegated wash

As for flat and gradated washes, you can apply bands of different colour or value to create a variegated wash. This technique is often used in painting skies and landscapes.

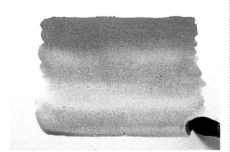

At first you may find that your wash appears a little stripy, but with practice you will come to know the delicate balance of pigment and water required to create a smooth, even gradation of colour.

Working wet on dry

Watercolour paint can be applied to either a wet or a dry surface. The effects produced are very different, and often the most interesting pictures are those which combine both methods. Working on a dry surface, the marks made have a sharp, well-defined edge and do not spread, and are therefore totally under your control. Painting wet on dry is sometimes called the 'direct' technique. It produces paintings that seem to sparkle with light because inevitably tiny patches of white paper will be left untouched by paint.

Rich colour effects can be obtained by applying a wash, allowing it to dry and then applying a second wash over it so that the underlying colour shows through. For example, try painting a wash of blue over a dry wash of yellow to create green. You will find the resultant colour more transparent and luminous than if you mix the blue and yellow together on the palette. This is because light is reflected back off the white paper through the thin layers of colour.

1 A wash of bright yellow is brushed onto paper and allowed to dry.

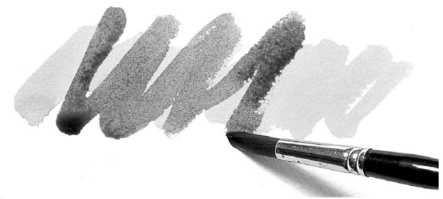

2 A transparent wash of blue is quickly brushed over the yellow to produce a green.

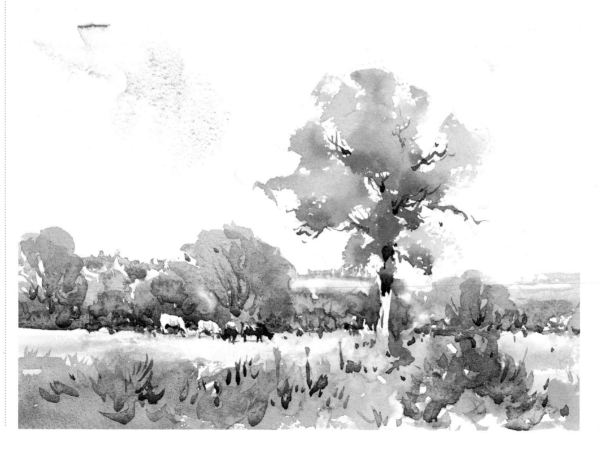

This sketch was done on dry paper using the 'direct' method of painting. Transparent layers of colour are applied one over the other.

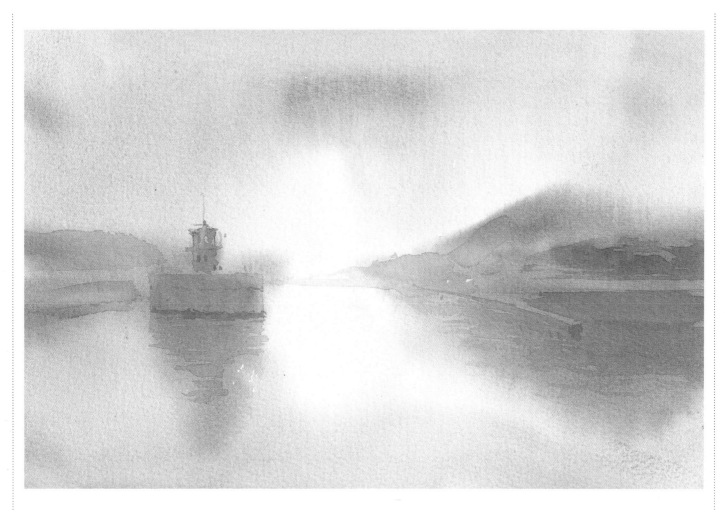

Painting wet in wet

Without doubt, the most beautiful and atmospheric effects in watercolour painting are produced by working wet in wet. In this technique wet colour is applied to wet paper, or wet colour is charged into wet colour. It allows the mixing of colours on the paper's surface rather than on the palette. The colours spread and merge gently together and dry with a soft, hazy quality. Wet in wet is particularly effective in painting skies and water, producing gentle gradations of tone that evoke the ever-changing quality of atmosphere and light.

Working wet in wet requires confidence and careful timing because you can only control the paint to a certain extent. Charge your brush fully and work quickly and confidently, allowing the colours to spread and diffuse of their own accord. A common mistake when working wet in wet is to dilute the colour too much, with the result that the finished painting appears weak and insipid. Because the paper is already wet you can use quite rich paint – it will soften on the paper but retain its richness. You must also compensate for the fact that the colour will dry lighter than it appears when wet.

It is best to use a heavy-grade paper, stretched and firmly taped to a board, to prevent it warping and wrinkling when wet washes are applied.

A 'wet in wet' painting in which the paint itself expresses the spirit of the place. A few small details were added at the dry stage to give the image focus.

This example illustrates the effect of a fully loaded brush applied to wet paper. Working wet in wet produces soft, diffused shapes that can be used to suggest clouds, mist and rain.

Creating highlights

Because watercolour is a transparent medium it is impossible to paint a light colour over a dark one; generally speaking, you have to plan where the light or white areas are to be and paint around them. This is one reason why it is so important to plan before you paint when working in watercolours. All the light areas and highlights must be carefully thought out and allowed for if you are to achieve a clean, pure watercolour painting and without resorting to the use of opaque white. It is wise to start with a pencil drawing to establish the correct position and shape of the highlights to be reserved.

In this small colour sketch the shape of the lake was stopped out with masking fluid to retain the brilliant white of the paper. Surrounded by the darker values of the landscape, it suggests bright light reflecting off the water.

Using masking fluid

Small, fiddly highlights which are awkward to paint around can be preserved by blocking them out with masking fluid prior to painting. Masking fluid is a liquid, rubbery solution sold in small bottles. Simply apply the fluid with a brush over the areas which are to remain white. It dries very quickly to form a waterproof seal, allowing you to apply washes freely over the paper without having to carefully avoid the white shapes. When the painting is completely dry the rubbery mask is easily removed by rubbing with your finger or with the corner of a clean eraser.

Never allow masking fluid to dry on your brush as it will ruin it. Wash the brush in warm, soapy water immediately after use to prevent the rubber solution from drying hard and clogging up the bristles. It is a good idea to keep an old brush handy for applying masking fluid, or buy a cheap synthetic one specially for the purpose.

1 Use an old brush to apply masking fluid to dry paper. Allow to dry thoroughly before painting over it.

2 Colour can now be freely washed over the masking fluid, which resists the wash.

3 When the paint is completely dry remove the mask by gently rubbing with your fingertip, revealing the clean white paper.

Lifting out

Another method of creating highlights is by gently lifting out colour from a wash while it is still wet, using a brush, a sponge or a tissue. Whereas masking fluid creates hard-edged highlights, lifting out creates softer, more diffused highlights, suitable when painting natural forms such as clouds, fruits and flowers.

It is also possible to lift out colour when the painting is completely dry. For soft highlights, try gently scrubbing off colour using a wet brush, a tissue or a cotton bud. For sharper, more linear highlights, use a sharp-edged tool such as a knife or a wooden toothpick. It is said that Turner sharpened his thumbnail into a point for scratching out highlights.

A final alternative is to use white gouache paint (an opaque form of watercolour) to add highlights to the finished painting. This can look clumsy and rather obvious, however, and should be used with restraint.

1 Lifting out colour with a tissue creates a soft effect.

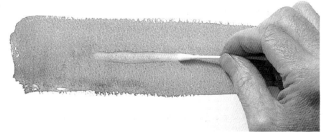

2 A cotton bud is useful for lifting out small, linear shapes.

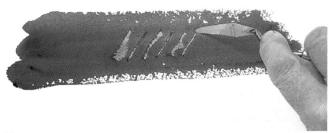

3 A sharp scrape at a slightly damp area gives textured effects.

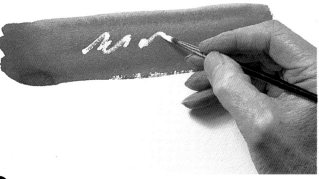

4 An alternative to lifting out is to paint over a dry area with opaque white body colour.

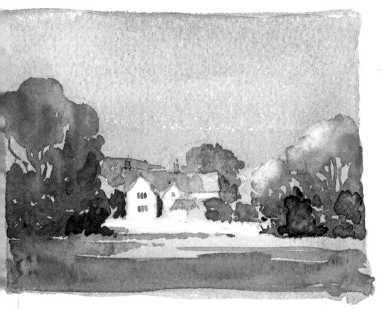

Once this painting was dry, colour was lifted out in parts of the central area to produce a sparkle of light. This area of high tonal value forms the focal point of the painting.

Combining Colours

The world of colour can be beautiful, but bewildering, especially for a beginner to painting. The artists' colour charts available show that there are nearly one hundred colours to choose from. All are wonderful and have a place, but if you are just starting out, you would be best advised to start with just a few. You can learn about colour by experimenting with different dilutions and mixtures of colours.

JUST AS A composer arranges musical notes to produce a melodious sound, so the artist should arrange his or her colours to create a harmonious image. The problem is that inexperienced painters often use too many colours, and use them at full intensity, so that the finished painting lacks subtlety and harmony.

One way to overcome this habit is to try painting with a limited palette of colours. Every school child knows that there are three primary colours – red, yellow and blue – and that all other colours can be mixed from these. Try it for yourself with alizarin crimson, Indian yellow and Winsor blue. Mixing any two of these together creates the secondary colours – orange, green and purple. If you mix all three primaries you can produce a wide range of greys and browns – the neutral colours.

Get to know the colours you can mix with the primaries, then you can begin to add to your range slowly and carefully. Buy only one more colour at a time and experiment again until you have discovered all the mixes possible. Some other colours which you might find useful are: French ultramarine, indigo, cerulean, viridian and the earth colours – yellow ochre, raw sienna, burnt sienna, light red and burnt umber.

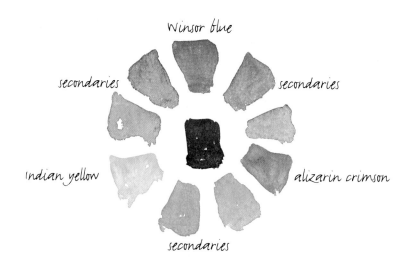

Winsor blue
secondaries
secondaries
Indian yellow
alizarin crimson
secondaries

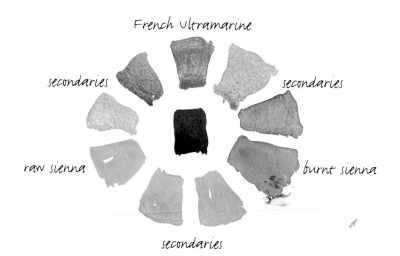

French Ultramarine
secondaries
secondaries
raw sienna
burnt sienna
secondaries

Experiment by mixing together the different reds, blues and yellows in your palette of colours and discover the myriad hues you can create. The three primaries used above produce a range of bright secondary colours, while those used below create a more subtle, neutral range.

Mixing two primaries together to form grey. A wide range of greys is possible simply by varying the proportions of blue and red in the mix (and the proportion of paint to water).

French Ultramarine

burnt sienna

Keeping your colours fresh

Watercolour has a transparency that sets it apart from other painting media. Light passes through to the white paper and reflects back through the colours with a translucent quality that gives the medium its characteristic luminosity. However, if colours are indiscriminately mixed on the palette, or if too many layers of colour are built up on the paper, they may cancel each other and turn muddy and opaque.

When mixing colours, don't be tempted to blend them so thoroughly that they become flat and lifeless. Colours which are partially mixed appear much livelier. Try placing the individual colours on damp paper and blending them just slightly so that they blend together wet in wet. Alternatively, use the wet-on-dry method and apply thin, transparent washes one over the other, allowing each layer to dry before applying the next. Try to avoid mixing more than two colours together; three or more colours tend to cancel each other out and make mud.

The wetness or dryness of the brush is a critical factor in controlling the density and tone of your colours. To produce dark colours, for example, squeeze the excess water out of the brush with your fingers before picking up the colour.

Always have plenty of clean water available as dirty water will contaminate your colours. Two pots are best: one to wash dirty brushes, and one to pick up clean water for mixing colours. Always rinse your brush thoroughly before picking up a fresh colour.

It is always a good idea to test a colour on a piece of scrap paper before committing it to the painting. It is better to get the colour right first time and apply it with confidence than to apply three or four weak, muddy layers in trying to get the colour you want. Finally, a word about paper. The unique white, light-reflecting surface of watercolour paper has a positive part to play in the freshness and luminosity of a painting. So don't be afraid to leave small areas of paper untouched as they will add air and light to your paintings.

Lively mixtures created by allowing wet colours to mix on the paper instead of in the palette.

Tonal Values

Painters often get confused between the terms colour and value. Value is the lightness or darkness of an area irrespective of its colour. The key to successful painting is understanding and controlling tonal values when you plan your paintings; they are more important than colour in organising a composition, suggesting form and conveying a sense of depth.

IN A BLACK and white photograph there are no colours – only tonal values, ranging from white, through various shades of grey, to black. Even so, it is quite clear what is going on because these values accurately portray the amount of light reflected by each object in the picture, enabling your eye to decipher what they are.

Although in nature there are an almost infinite number of tones between black and white, the naked eye is only capable of distinguishing between six and nine comfortably. In practice, you don't even need this many in a painting: it is possible to produce a perfectly clear image using only five or six tones. By simplifying tones and grouping them together, you create a strong and cohesive image that makes an impact on the eye. If the tones are too many, and too scattered, confusion results and the eye quickly becomes tired.

Before you start painting, observe your subject and establish the lightest light and the darkest dark. Then compare the relative tonal values between these two extremes. If you find it difficult to distinguish the different tones, try screwing your eyes up until you can only just see through them. This eliminates most of the detail and colour, enabling you to concentrate on tonal values more easily.

Look at the overall scene as well as individual areas and compare one tone in relation to another. How much darker is the foreground than the sky? Are the trees darker than the foreground or lighter? Once the main value masses are established correctly, it is much easier to develop the shapes and forms within them.

Get into the habit of making small tonal sketches (see pages 32–4) as a means of organising the distribution of tones. When you have finished your drawing, you have a complete plan for a painting. You can look at your drawing and see instantly, working from light to dark, the order in which the watercolour layers must be applied.

Atmospheric perspective

Due to the effects of atmospheric haze, objects in the distance appear lighter in tone than those close to us, and detail and contrast diminish. In order to create the illusion of space and distance

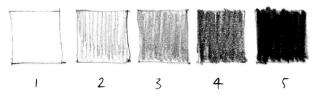

1　　2　　3　　4　　5

A VALUE SCALE

A value scale like the one shown here is useful in gauging the values of the objects you are painting. Simply give each area of colour a tonal value from one to five on the scale, depending on how light or dark it is.

Start by drawing a row of five squares on a sheet of white paper. Leave square 1 as white paper. Fill in square 5, making it as black as you can by exerting pressure on the pencil. Now fill in squares 2, 3 and 4 with hatched lines, carefully grading them from light to medium to dark.

LAYERING OF VALUES

Working from the lightest tonal value to the darkest, most paintings can be completed in three or four layers, one applied over the other. The darkest values are usually found in the foreground, particularly in landscapes.

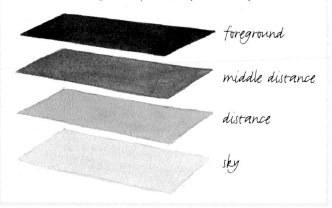

foreground

middle distance

distance

sky

in your landscape paintings you should reproduce these effects by reserving the strongest tones, and tonal contrasts, for the foreground. As you move towards the horizon, use weaker tones and reduce the degree of detail and contrast.

Tone and composition

The arrangement of lights and darks within the picture is an important aspect of composition. Passages of light or dark value create visual interest and help to move the viewer's eye through a painting. Strong value contrasts can create emphasis where you want it in a picture, because they tend to attract the eye, and they should therefore be reserved for the centre of interest.

Tone and mood

There is a strong connection between the tonal range of a picture and the mood it conveys. A painting which consists primarily of the darker values in the range gives a sombre and serious atmosphere whereas a painting with a full range of tones, bright highlights and crisp shadows creates a lively and cheerful impression. Think about how to orchestrate the tonal quality of your painting to illustrate the mood you wish to convey.

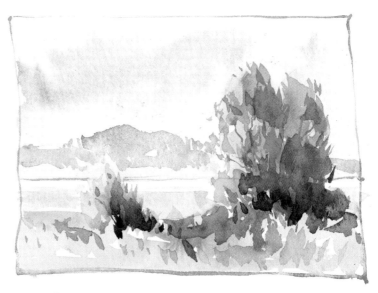

The illusion of receding space is created in this landscape by keeping the distant colours pale and blue and the foreground colours darker and warmer.

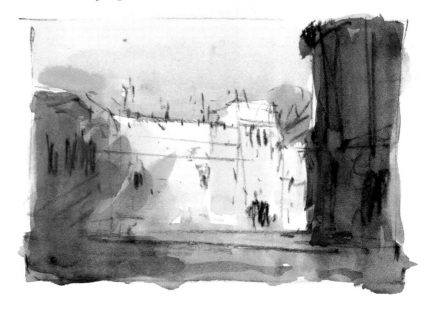

While on holiday I suddenly came upon this scene, with the distant building 'spotlit' by the sun. I made this quick tonal sketch to explore the dramatic possibilities of light/dark contrasts.

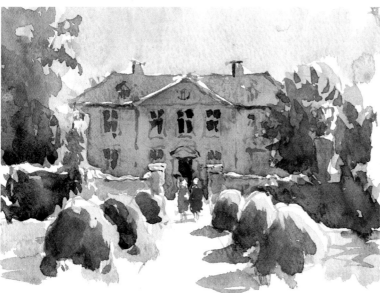

A low light source directly behind the subject produces lovely effects because the subject is thrown mostly into shadow, with just the outer contours brightly lit.

Composing Your Pictures

Good composition means selecting the shapes, colours and values in your picture and then arranging them so that they balance beautifully within the borders of the frame. Although this process quickly becomes instinctive as you gain experience, there are several basic rules to get you thinking along the right lines. It is worth knowing the rules as you learn, but your paintings need not follow a formula.

PROFESSIONAL ARTISTS TEND to distrust 'rules' about composition, arguing that every rule has been broken by a Great Master at some time or another. But you can only break the rules successfully once you know what they are, so keep the guidelines described here in the back of your mind until your compositional sense has had a chance to develop. Later, you will know automatically what makes a picture 'work' and you will then be able to start experimenting with more unorthodox ideas.

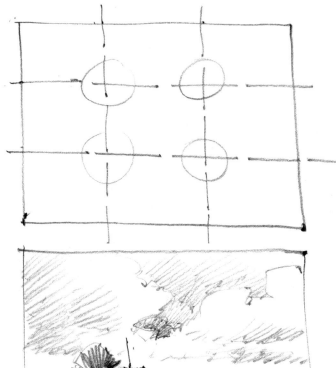

Before starting your sketch, try drawing a grid like this one on the page, dividing the area into thirds horizontally and vertically. Use one of the horizontal lines to place the horizon. Then use a vertical line to help place the focal point of the picture, as in my sketch.

Creating a focal point

A picture should ideally have one focal point – an area to which the eye is naturally drawn and thus forms a resting place.

Without it, the viewer's eye wanders around the picture without knowing where to linger. It is important to consider where the focal point will be before you start painting; once this is decided, the rest of the composition can be arranged around this point.

A good way to draw attention to the focal point is by reserving the strongest contrasts for that area – light against dark, warm against cool, bright against neutral, large against small. You may have secondary points of interest, but make sure they don't compete for attention with the main focal point.

The rule of thirds

It might seem logical to place the focal point in the middle of the picture, but in fact that appears static and boring because it divides the picture area into two equal parts. To produce a balanced, satisfying composition try using the 'rule of thirds'. Divide your format into thirds vertically and horizontally. The intersection of the thirds produces four 'ideal' positions for the centre of interest. Placing it off-centre often creates a more dynamic image than one with a central emphasis.

Placing the horizon

In landscapes, deciding where to place the horizon is an important way to give emphasis to your subject and to balance the composition as a whole. Placing the horizon in the centre of the picture is not advisable. Like a centred subject, it has the effect of dividing the composition in two, leaving the eye undecided where to go. To give your pictures more visual impact, try placing the horizon either above or below the centre. For example, if you want to emphasise a dramatic sky, place the horizon line low down in the picture space.

A low horizon line emphasises the sky area and helps to create the illusion of space and distance.

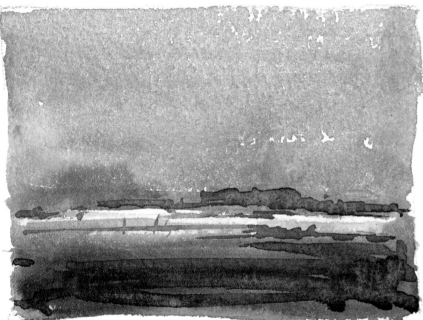

Here you can see the low horizon principle employed in a quick colour sketch.

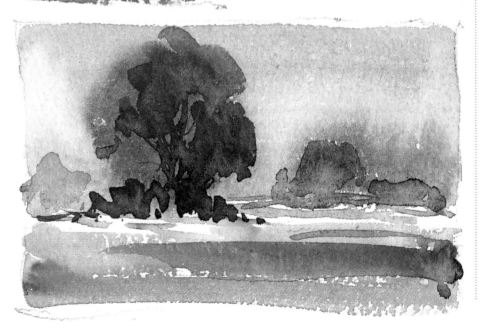

Another test sketch to try out a compositional idea using the principle of the rule of thirds. Notice where the horizon and trees are placed.

In this sketch of a simple still-life, the rule of thirds has again been applied. In addition I have chosen the objects with care and arranged them in such a way as to introduce unity, diversity and contrast.

Here, the whole composition is balanced, but too symmetrical to be interesting.

Unity and diversity

A picture should appear balanced and harmonious, while containing enough variety to keep the eye entertained. For example, the repeated use of related shapes and colours creates unity, but we need to recognise that too much repetition can be monotonous. To prevent visual boredom, try to combine unity with diversity and contrast. For example, include at least one vertical object in a mainly horizontal image; offset busy areas with peaceful areas; contrast softness and wetness with crisp, sharp strokes; or introduce a spot of bright colour into a low-key painting.

In this sketch the horizon cuts the picture in two horizontally and the tree cuts it in two vertically, again creating a dull composition.

Balance and design

You need to think about the relationship between the shapes and masses in your picture. The weight of colour or value in one section of the painting should be counterbalanced by similar colours or values in another section.

Look for lines and shapes that flow through the picture and link one area to another, leading the eye around the scene. The painting will look disjointed if there are too many shapes dotted about the composition without any means of connection.

This sketch is balanced yet lively. The rule of thirds has been used successfully, the large tree is balanced by the smaller one, and the curved road leads the eye into the picture.

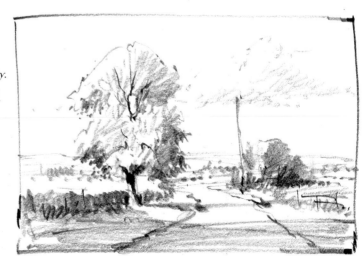

Using a viewfinder

When we look through the viewfinder of a camera we are using it to isolate an area of interest from the overall view. Once we are satisfied with the image seen through the viewfinder we press the shutter and the scene is captured on film.

In a similar way you can use a simple cardboard viewfinder to isolate a particular section of a scene you wish to paint. By framing the subject in this way you can check that it makes a satisfying composition.

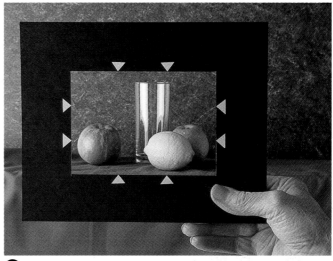

3 Close one eye and look through the frame. Move it towards and away from you, up and down, to left and right, until the subject is framed in a pleasing way.

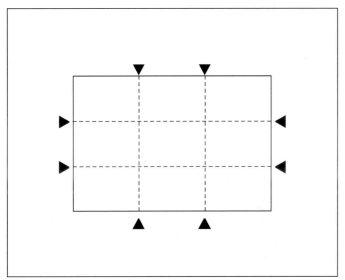

1 To make a viewfinder, use a strong piece of card measuring about 20 x 25cm (8 x 10in).

2 Cut out a central window measuring 10 x 15cm (4 x 6in).

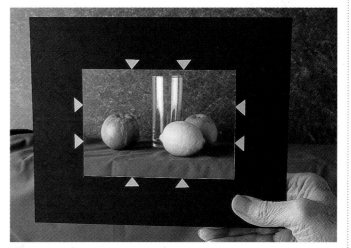

4 Now move the viewfinder so that the focal point rests on or near a point where two of the grid lines intersect.

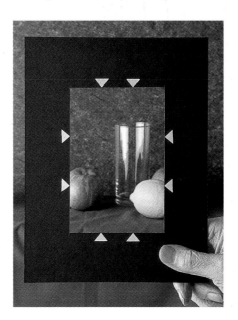

5 You will be amazed to discover many more potential paintings in one scene than you had first imagined. Use your viewfinder constantly; you will find it an invaluable aid in finding and planning good picture ideas.

How to Plan Your Paintings

This is perhaps the most fascinating stage of the painting process. It is when the imagination comes into play, when you begin to develop an idea based on something you have seen and which inspired you to pick up your paints. There is plenty to think about and plan for in order to realise that idea: the format and composition of the picture, the palette of colours, the techniques you might want to use, and so on. Good planning is the key to successful watercolour painting.

Preparation for Painting

In painting, failure is usually the result of impatience to produce a finished work to hang on the wall, without stopping to think about what you want to say about your subject or how you are going to approach it. This section will help you to discover a more logical approach that will enable you to produce well-planned paintings of which you can be really proud.

WATERCOLOUR PAINTING DEMANDS careful planning and judgment, even before you have put brush to paper. If you think this sounds like a chore, please think again. Launching into the painting without any pre-planning often ends in frustration and disappointment. More importantly, you will miss out on a whole lot of fun! The process of thinking and planning, observing your subject from different angles, deciding on mood, lighting, colour and tonality, making thumbnail sketches and studies – all of this pre-paratory work is actually one of the most absorbing and satisfying parts of the painting process. Watercolour painting involves many fascinating aspects. It can be a science, involving the study of light, colour and tonal values. It is also an absorbing craft in which one learns how to use one's tools and materials to produce specific effects. Above all, it is a fascinating voyage of personal discovery.

So let us look at what is involved. Basically, any creative process must progress through three stages:

 1 The idea of inspiration
 2 Making a plan
 3 Executing the plan

Suppose one day you decide to re-decorate your living room. You don't just slap on some paint and hope for the best. You start out with an idea, a particular look you want to achieve. You then start planning the colours and

furnishings that will create that look. You make sure you have the right tools and equipment to tackle the job. When you have carefully worked it all out you are ready to start, confident in the knowledge that it is all going to come together. Good planning makes the work easier and the end results better. And exactly the same approach applies to painting pictures.

The idea

Deciding *what* to paint is probably the most difficult stage. Get into the habit of looking at your surroundings through a viewfinder (see page 29). You will find it a great help in finding interesting compositions and generally sparking off ideas.

Before painting a picture it is im-portant to know why you want to record the subject or scene and what it is about it that attracts you. Take the time to observe your subject carefully. If the subject is a landscape, is it the sunlight on the trees that pleases you? Or perhaps the repeat patterns created by clouds, trees and hills? Until you become aware of exactly what is attracting your attention you cannot know how to go about painting it.

Planning

Having determined the subject and the general mood you want to express, some planning is necessary to transfer the initial mental image to the paper.

Make sketches and studies in your sketchbook like the ones shown here. Keep them simple and small in scale. Your sketches should be unlaboured and spontaneous; try to capture the *spirit* of the subject and not get bogged down in detail. Tiny 'thumbnail' sketches can be drawn in a few minutes and will help you to organise the placement of figures, trees and so on. A soft pencil is the best tool as it gives a range of tones from silvery grey to deep black. You may find that a short, stubby pencil is easier to hold than a long one and helps to free up the hand and arm movements, producing more fluid marks.

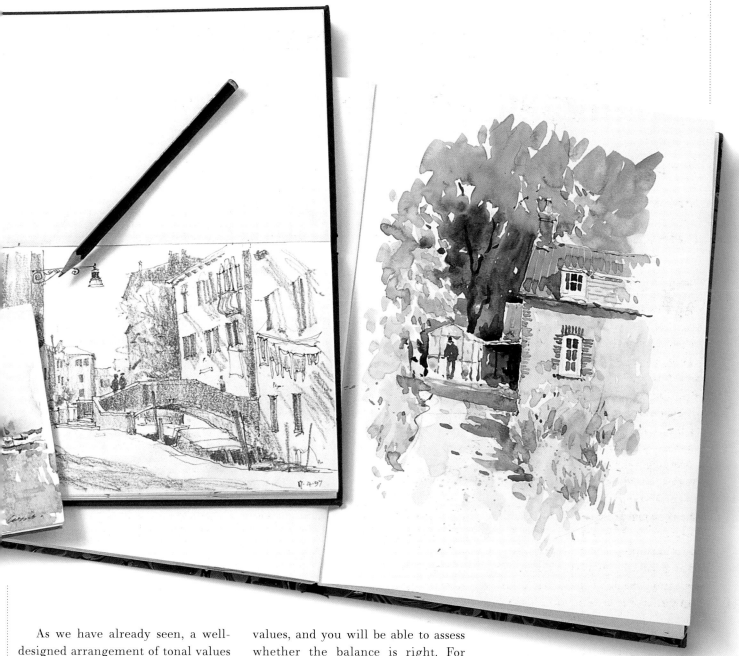

As we have already seen, a well-designed arrangement of tonal values will hold a picture together and give it a balanced design. A successful composition consists of a few large masses of light, dark and middle tone, rather than a lot of small, fragmented tones.

It is worth making tonal sketches, perhaps slightly bigger than the thumbnails, in which you can test and organise the placement of lights, mid-tones and darks. Mass closely toned areas together so that you create a pattern of fairly large, flat, abstract shapes. Reduce your subject to its simplest light, medium and dark values, and you will be able to assess whether the balance is right. For instance, a large mass of dark tone on one side of the picture will look unbalanced, so introduce an area of dark tone on the other side as a counterbalance.

Sketches are an excellent way of simplifying a complex scene and of getting to know the subject before you begin to paint. They sharpen your perception, and you begin to see your subject in pictorial terms. In the long run, making sketches like these saves time, as it is much easier to alter things at this stage than when the painting is well under way.

Tonal and coloured sketches become good solid plans for paintings. They help to eliminate unnecessary details and to clarify the image in your mind before you start on the painting proper. These sketches are never a waste of time and are most enjoyable to do.

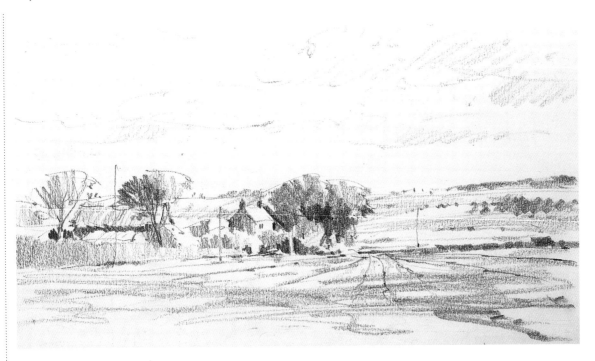

1 I start by observing the scene through my viewfinder and deciding what to put in and what to leave out, and where to place the focal point. Then I make a pencil sketch to test out my ideas and, most importantly, to plot the positions of the lights, darks and middle tones.

2 The process of sketching the scene has helped me to work out how I will approach the painting. I can't wait to get started, but first I must sketch the main outlines of the composition onto the watercolour paper.

Executing the plan

By this stage you should be well prepared to paint a successful picture. You know what you want to say and how you are going to say it, and you should almost be able to see the finished painting on your blank sheet of paper.

From your preliminary sketch you can now copy the bones of the image onto the watercolour paper with light pencil lines. Use a well-sharpened, medium-grade pencil such as an HB or 2B. A pencil that is too soft will smudge when erased, and one that is too hard

may incise lines into the paper. Hold the pencil lightly and with sweeping movements of the arm (not just the hand) lightly rough-in the basic shapes. Pay attention to how the drawing fits onto the page. Work over the entire page, not just isolated areas. If you make a mistake, simply go over it with the correct line. If you must erase, do so lightly so that you don't disturb the natural surface of the paper.

You are now ready to begin painting in watercolour. Hopefully you have enjoyed the planning process and

learned from it. And sorting out all the potential problems before you begin painting does wonders for your confidence. It means that you can work directly from light to dark without making corrections, so your finished painting will hang together better and will be fresher and more in control.

The next section of the book explains the process of painting from light to dark in watercolour, accompanied by step-by-step demonstrations by a range of different artists.

How to use this Chapter

This book has been designed to lead you through the different stages of building up watercolour pictures, so that you can then apply these techniques to your own paintings. Each section of this chapter focuses on one aspect of watercolour painting, such as creating atmospheric effects or the art of painting details.

Each section within this chapter starts with an introduction about its focal theme. This will lead you into the subject or introduce a new technique. An example of a completed painting is shown, and the author explains how it makes use of the new technique or style discussed.

Swatches or diagrams highlight the new technique or style

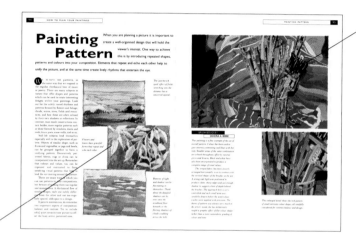

A painting by a contemporary artist is analysed to illustrate how the new technique has been used

Step-by-step shot of how the picture is built up and which colours to mix at each stage

Introductory analysis of the painting

List of paints and materials you will need

Sketch to show the basic structure of the painting

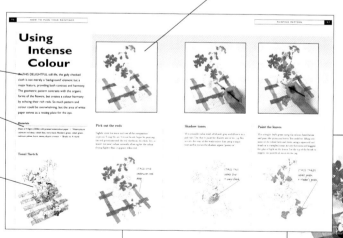

Finished painting to show how all the layers have built up to complete the composition

Within each section there are two step-by-step demonstrations by different artists, each using the new technique to contrasting effect. These demonstrations take you through each of the stages which the painter has used to create the whole composition. At each stage you can see exactly which colours the painter has added and how the picture is gradually building up.

Separate picture showing the colours and colour mixtures which are added in each layer

Painting Light to Dark

This section explains and demonstrates the painting method known as tonal layering, or working from light to dark. Because watercolour is a transparent medium, light colours cannot be applied over dark ones. Therefore the most logical way to complete a watercolour painting is to apply the lightest values first, then the middle values, and finally the darkest values.

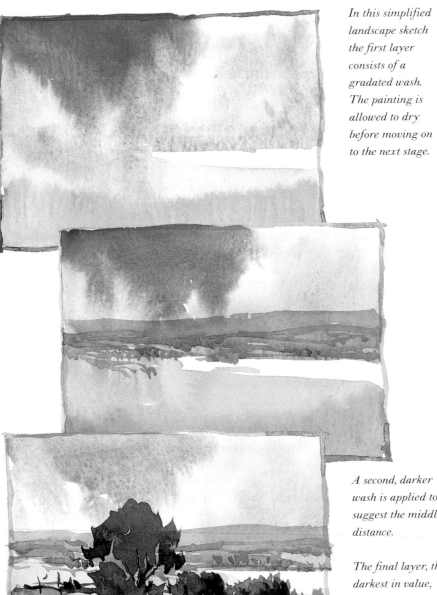

In this simplified landscape sketch the first layer consists of a gradated wash. The painting is allowed to dry before moving on to the next stage.

A second, darker wash is applied to suggest the middle distance.

The final layer, the darkest in value, brings the foreground forward, giving the illusion of receding space.

IF YOU HAVE been paying attention so far, you will know how valuable a preliminary sketch is to the success of your watercolour paintings. A simple pencil sketch will show you at a glance where the lights, middle values and darks are going to be, so you know in advance in which order to apply the layers of paint to the paper. Nothing could be simpler!

Now all you have to do is apply the first, lightest wash of colour. If any area of the image, such as the top of a sunlit cloud, is to be left as white paper, you can either paint around it or block it off with masking fluid and wash right over it. Once the background wash has dried, you can apply the second layer – the middle value colours – over the first layer, leaving uncovered any areas that are to remain light in value. Remember always to allow time for each layer of paint to dry before overlaying the next layer of colour. If you do not, the two colours will simply mix together or the wash may dry with unwanted marks and ridges. If you are working indoors, a hairdryer can be used to speed up the drying process if necessary.

Layer three – the darkest values – is applied next, remembering to allow layer two to dry first. This may well complete the painting, or you may wish to add one or two darker details, which would be layer four.

This methodical approach makes sense, because you cannot afford to

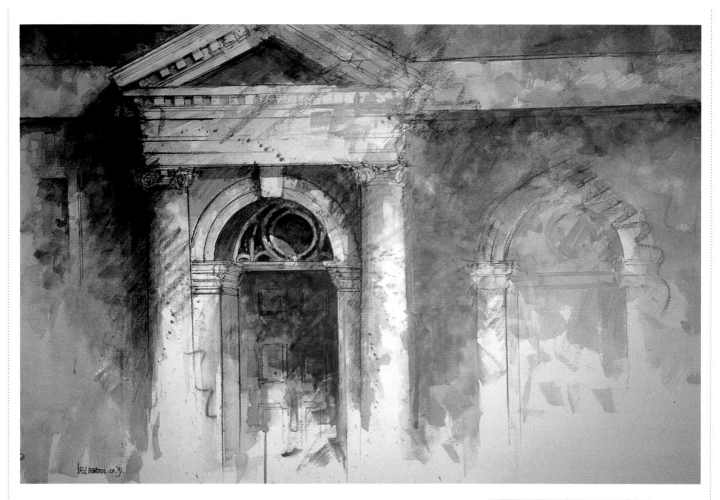

make mistakes in watercolour. If you plunge in with both feet and then start changing your mind and prodding the paint around, you will find that the colours turn muddy and the result is that you begin to lose the freshness and translucency that is the hallmark of a good watercolour painting.

If, on the other hand, you use the tonal layering technique and plan things in advance you will have the confidence to lay a wash and leave it to settle undisturbed before moving on to the next one. When your painting is complete you should end up with a series of smooth, transparent washes that allow light to reflect up through them from the paper, giving the colours a marvellous luminosity. Starting with large, pale washes, then overlaying them with a range of increasingly darker colours and values, enables you to build up a rich, translucent quality to your watercolour paintings.

THE BLUE DOORWAY
NEIL WATSON

This study of a classical doorway has a wonderful painterly quality which results from the contrast of loose washes and carefully detailed drawing. Leaving the lightest parts of the image as bare paper, the artist used a flat brush to apply very pale strokes of colour, almost randomly, over the walls and door. He then continued with a series of darker washes applied wet-over-dry to give depth, value contrast and liveliness to the picture. The loose brushstrokes enliven the image and also suggest the texture of ancient, weathered stone.

The shadowy interior of the porch is not painted with a single heavy wash of dark colour; instead the artist builds up wash over wash to achieve a palpable sense of shadow and reflected light.

Tonal Layering

A SIMPLE, OPEN landscape like this one lends itself perfectly to the classic watercolour technique of working from light to dark.

The key factor in the success of this picture is the carefully observed pencil sketch made initially, in which the artist recorded the main shapes and masses of tone. The sketch is a complete plan for the painting, indicating the order in which the successive watercolour washes should be laid. It can be seen from the drawing that the distant sky is light, as is the riverbank. The distant mountains are pale and blue, to give them recession. The nearer mountains and trees are applied next, and finally the dark trees and water reflections are painted.

Materials

Sheet of 410gsm (200lb) cold-pressed watercolour paper • Watercolours: French ultramarine, light red, raw sienna, burnt sienna, cadmium red, permanent rose, Indian yellow, indigo, lamp black • Brushes: 25mm (1in) flat, no. 14 round • Dip pen

Tonal Sketch

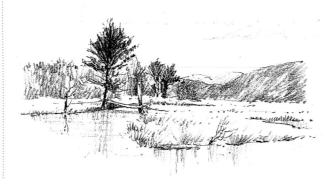

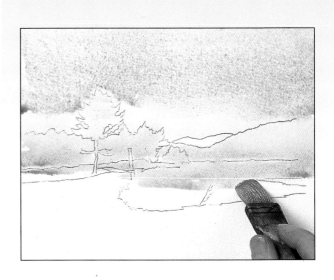

Apply the underwashes

Mix a warm blue and a warm yellow (see below) in separate areas of the palette. Dilute the colours with plenty of water to make them pale and transparent. Load the 25mm (1in) flat brush with the blue wash and paint the top two thirds of the sky. Rinse your brush and paint the bottom third with the yellow wash to represent the glow of the setting sun. Carry this down over the middle ground, then switch back to the blue wash for the water.

STAGE ONE
French
ultramarine
+ light red

raw sienna
+ burnt sienna

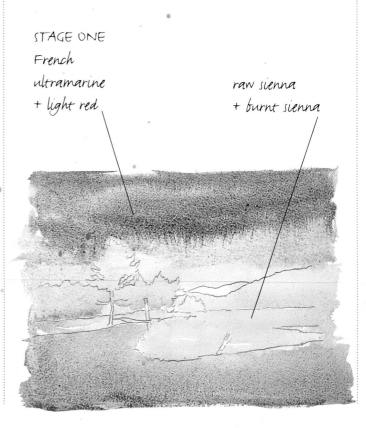

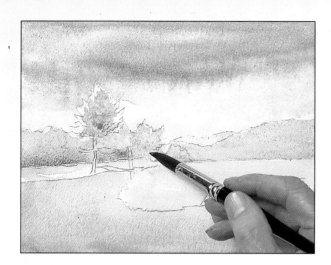

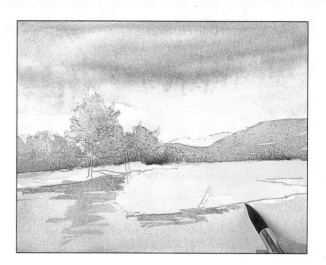

The distant landscape

Check that the background washes are completely dry
before starting to build up the colours and values in the
landscape. Prepare a wash of slightly stronger blue and
apply this over the trees and the distant mountains with
the no. 14 round brush. Leave the painting to dry.

The middle distance

Now begin to strengthen the values in the middle distance
– the trees, the nearer mountains and the reflections in the
water – with a further wash of blue, this time with a
violet tinge. The value of each colour layer has to be
carefully considered, and it is a good idea to test the colour
on a piece of scrap paper first. Notice how this wash has
pushed the more distant mountains back, emphasising the
illusion of the landscape receding into the distance.

STAGE TWO
French
ultramarine
+ a little
cadmium red

STAGE THREE
French
ultramarine
+ permanent
rose

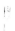

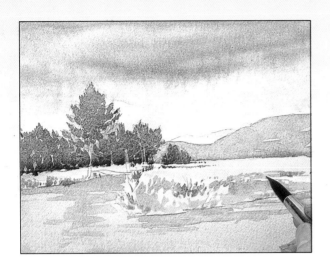

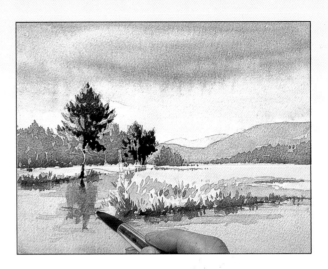

Add warm and cool colours

Just as weak values appear to recede while strong values advance, so cool colours recede and warm colours advance. So, to further accentuate the feeling of space and distance, apply a wash of cool green over the trees and then suggest the dry reeds and grasses in the foreground with warm earth colours (see below). Leave the painting to dry.

Work up to the darks

Now give the painting some 'punch' by putting in the darkest darks. Mix a very dark green for the shadowed parts of the centre tree, the foreground tree and its reflection in the water. Mix a deeper shade of brown for the shadows in the reeds and their reflections in the water.

STAGE FOUR
French
ultramarine
+ Indian yellow

burnt sienna
+ raw sienna
+ cadmium red

STAGE FIVE
indigo
+ Indian yellow
+ lamp black

burnt sienna
+ cadmium red

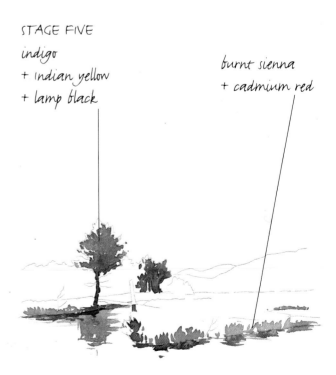

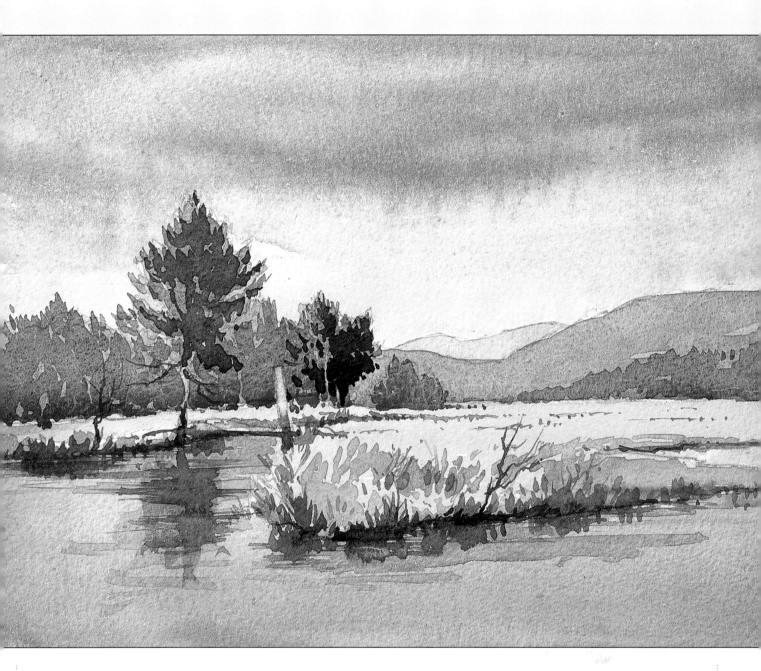

STAGE SIX
burnt sienna
+ lamp black

Strengthen some of the shadows in the foreground with strokes of very dark brown and paint the base of the wooden bridge post. Then darken the wash still further and finish off by drawing in the dry branches sticking out of the water with a dip pen. Use a brush to load the paint on to the pen nib.

Keeping Colours Fresh

THE FLUID AND transparent nature of watercolour makes it ideal for capturing the graceful forms of flowers. This simple vase of sunflowers was painted wet in wet, the artist applying the colours quite spontaneously and allowing them to merge together on the damp surface.

 The artist's first step was to make a pencil sketch, to define the main areas of light and dark in the subject. By establishing the tonal and colour values in advance, the artist knew exactly where to start and in what order to build up the tonal layers from the lightest to the darkest values. Thus she was able to apply her colours with confidence and allow the washes to settle undisturbed. Fresh, clear colours are essential in flower painting.

Materials

Sheet of 410gsm (200lb) cold-pressed watercolour paper • Watercolours: cobalt blue, Winsor blue, Winsor violet, quinacridone gold, aureolin, Prussian green, sap green • Brushes: no. 12 round

Tonal Sketch

The background tints

Draw the outlines of the flower arrangement lightly with a soft pencil. Wet the entire picture surface with clean water using the no. 12 round brush. While the paper is still damp apply loose washes of pale blue, violet and yellow to the background, then apply pale yellow to the flowers and leaves. Allow to dry completely.

STAGE ONE
Winsor violet

aureolin

cobalt blue

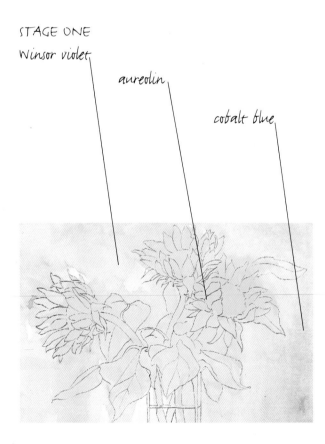

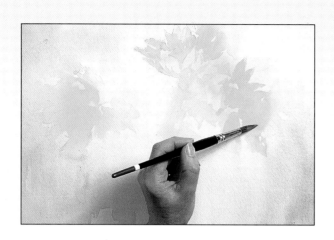

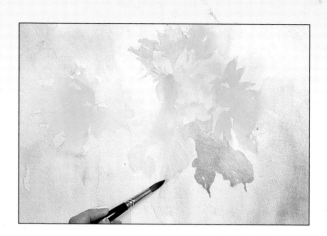

Strengthen the flowers

Mix a deeper shade of yellow (see below), still keeping the wash thin and transparent. Dampen parts of the flower heads with water, then apply the colour and allow it to spread; this will produce interesting lost-and-found edges. Don't worry if the washes flow over the drawn lines as this lends a sense of life and movement to the flowers.

Work on the foliage

Starting with the two transparent greens listed below, define the middle values of the leaves, again pre-wetting the paper in places to allow the colours to bleed across the pencil lines. While these first washes are still damp, drop into them some blues, golds and violets. This wet-in-wet technique produces lively gradations of colour. Allow the painting to dry.

STAGE TWO
aureolin +
quinacridone
gold

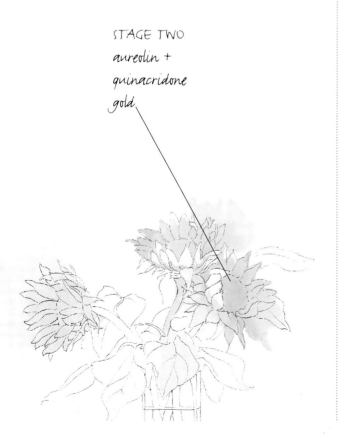

STAGE THREE
quinacridone
gold
sap green
Prussian green
Winsor violet
cobalt blue

sap green

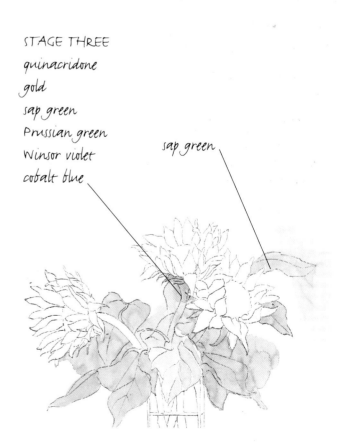

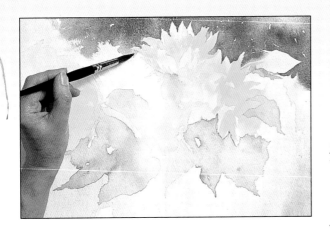

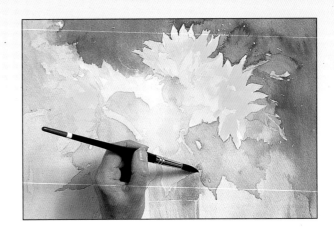

Add background shadows

Mix separate washes of blue and violet in your palette. Sweep in broad, loose strokes across the upper right-hand corner of the picture. Vary the washes by allowing the three colours to mix together on the paper. Work carefully around the shapes of the sunflower petals. Allow a thin wash of violet to overlap the flower on the left-hand side, which is in shadow.

Work on the vase

Use blues and greens to suggest the shadowy tones of the glass vase. Once again, work wet in wet so that the colours blend together softly. Leave thin slivers of white paper to indicate the reflections on the corners of the vase and on the surface of the water inside it.

STAGE FOUR
Winsor violet

Winsor violet
Winsor blue
cobalt blue

STAGE FIVE
Prussian green

cobalt blue
Winsor violet

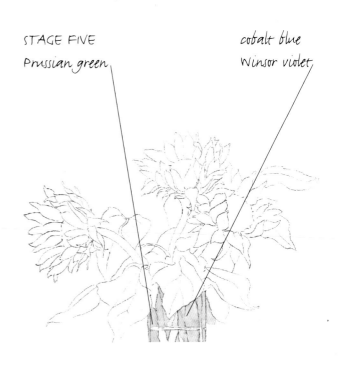

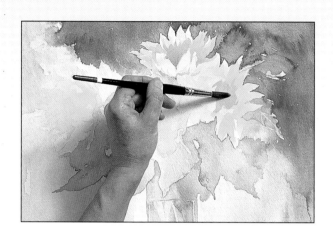

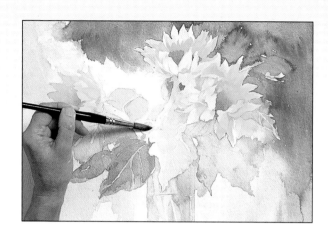

Define the sunflowers

Start to define the shapes of the sunflower heads by modelling with light and shade. Mix a warm, golden yellow and paint the flat centres of the flowers and the shadowed parts of the petals. When dry, add further layers of colour to suggest deeper shadows. Mix a cool, transparent shadow tone of blue and violet and wash this over the petals of the left-hand flower, which is in deeper shade than the others.

STAGE SIX
quinacridone
gold + Winsor
violet + cobalt
blue

quinacridone
gold

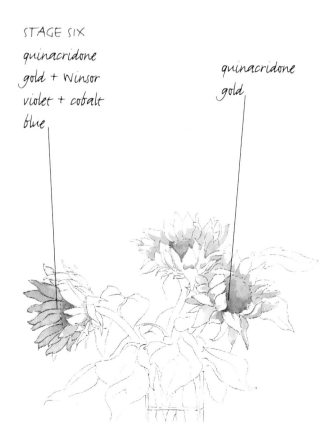

Define the leaves

Now start to define the forms of the leaves with more overlay washes. Mix a variety of greens, blues and violets, both warm and cool (see below). Keep the washes thin and transparent and apply wash over wash, gradually modelling the forms of the leaves. Observe which parts are in shadow and which face the light and paint them warm or cool accordingly. Leave thin slivers of white paper to suggest the veining on the leaves.

STAGE SEVEN
sap green
Prussian green
Winsor blue
Winsor violet

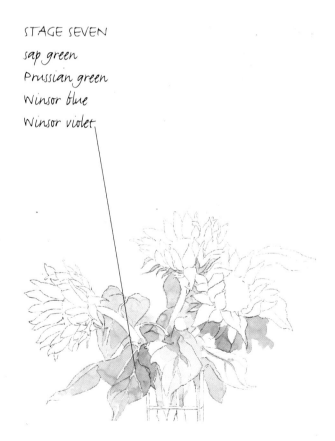

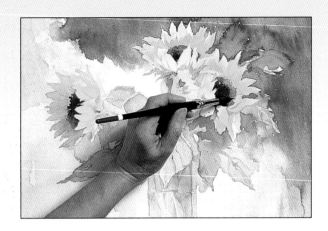

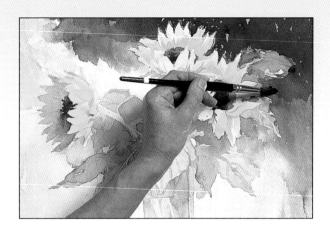

Add darker values

With the light and middle values established, the darker values can now be applied. Mix golden yellow with a touch of violet and use this to define the darker parts of the sunflower heads. Remember always to gradate the washes to keep them interesting.

Darken the background

To emphasise the bright, warm colours of the sunflowers, the background needs to be darkened down with further washes of blue, green and violet. As before, mix the three colours separately and apply them wet in wet so that they flow together on the paper, being careful not to go over the edges of the flowers. Using the same blues and greens, darken the leaves on the shadow side of the arrangement.

STAGE EIGHT
quinacridone
gold + Winsor
violet

STAGE NINE
Prussian green
Winsor blue

Winsor violet
cobalt blue
sap green

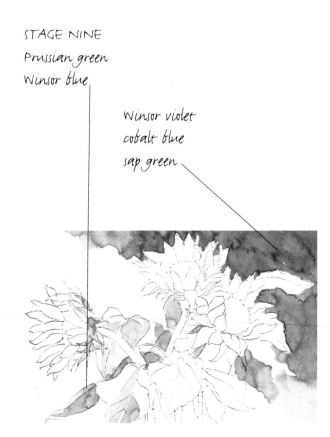

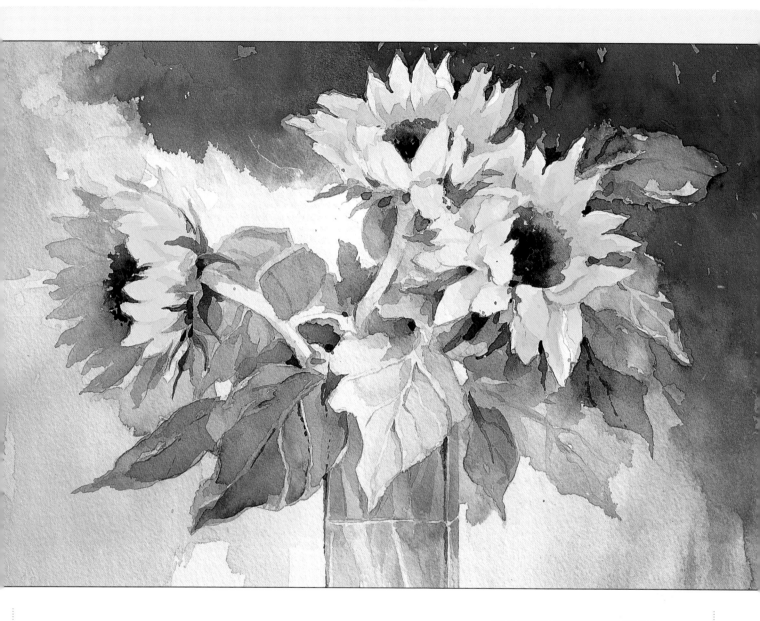

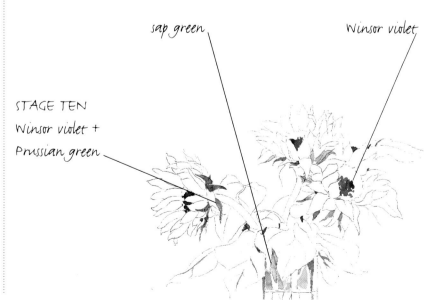

sap green

Winsor violet

STAGE TEN
Winsor violet +
Prussian green

ADALENE FLETCHER

The final touches of dark, cool shadow colours may now be applied. Mix varying shades of cool greens and violets and apply as shown using the tip of the brush. Throughout the painting each layer of wet paint should have been allowed to dry completely before moving on to the next. If you are working indoors, a hairdryer can be used to speed up the drying time. The finished painting has a lively quality because the artist has exploited the contrast between the bright, warm flowers and the cool, dark background.

Painting Light to Dark

BOTH OF THESE two paintings show the light to dark method used to good effect, and both make use of the wet into wet technique to establish an atmospheric background. Although light areas cannot be reserved when the paper is damped all over, as in 'Brighton Beach' they can be created by carefully washing off colour to produce gentle soft-edged lights. Alternatively, highlights can be reserved by leaving these areas of the paper dry, so that the colour does not flow into them.

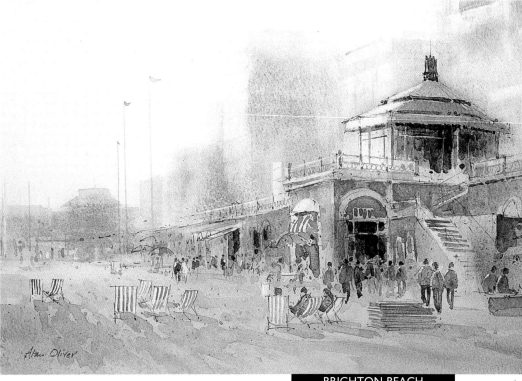

BRIGHTON BEACH
ALAN OLIVER

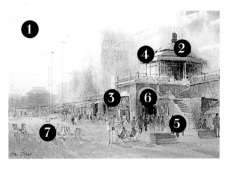

Working order

The painting was done from a combination of memory and a tonal sketch made on the spot. The artist used only five colours: raw sienna, light red, French ultramarine, cerulean and viridian.

1 No preliminary drawing was made. The paper was damped all over with clean water, and a series of soft background tints was laid on with a 2mm (1½inch) flat brush. Raw sienna was used for the sky, cerulean and viridian for the distant buildings, and light red mixed with ultramarine for the foreground.

2 When the paper had thoroughly dried, a pen was used with brown ink to sketch in a few key outlines and details.

3 Gradually working up to the darks, middle values were then applied, using a mixture of ultramarine and light red.

4 Some areas of paint were washed off to produce soft highlights.

5 A few figures in the middle distance give life and scale to the scene.

6 For the darkest values, the ultramarine and light red mixture was again used, but in less diluted form.

7 Finally, some crisp highlights were added to give more contrast to the painting, using white gouache paint.

Key Planning Points

- Plan the composition and distribution of tonal values before you paint
- Get plenty of colour washes ready mixed before starting
- Once started on the background, work quickly, before the paper begins to dry

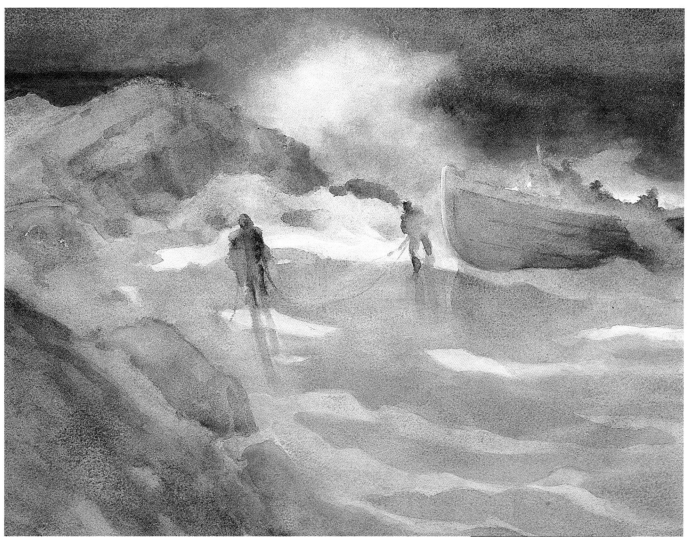

NIGHT LANDING

JOYCE WILLIAMS

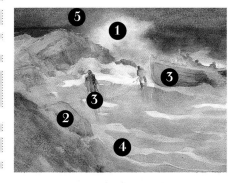

Working order

The artist developed this painting from the memory of a personal experience. She made several sketches to perfect the design, moving elements around to produce an exciting composition.

The colours used were aureolin, rose madder, cobalt blue, ivory black and manganese blue.

1 A light wash of aureolin and rose madder was flooded over the whole paper except the white water areas.

2 When the first wash was dry the same colours, with the addition of cobalt blue, were used for the rocks, boat and figures. The colours were laid separately and allowed to blend on the paper.

3 The first washes were then left to dry, and shadows were added to the rocks, boat and figures, using rose madder and cobalt blue.

4 The two blues, plus aureolin, were used for the rocks, and the blues alone for the shadows over the water areas.

5 The sky was then washed in using glazes of all three colours plus black, with more black added to the sea, and taken around the white water areas. The edges of these were softened, with any hard edges of overlapping colour gently washed off to retain the light.

Key Planning Points

- Observe movements like those of waves carefully and commit them to memory
- Try devising a painting from memory alone. If you fail, practise this art – it can be very useful

Painting Detail

There are no hard-and-fast rules about how much detail to include in a watercolour painting. It is entirely up to the artist and his or her emotional reaction to the subject, and some subjects naturally demand a more detailed treatment than others. You need to find a level of detail which does not look overworked, even if your subject appears at first sight to be very intricate.

I T IS WORTH remembering that painting is not about copying nature but translating it. If you try to say too much you may end up saying nothing well. You have to learn to be selective − to identify what is most important about the subject and to exclude or simplify anything that might compete with it. One way to proceed is to work from the general to the specific. Divide your picture into broad, general areas first, and then introduce the details and smaller passages.

The eye is drawn to an area of detail or strong contrast, so concentrate these around the focal point of your picture and play them down elsewhere. Some of the most satisfying pictures contain a small area of detail offset by broad, restful passages that provide a welcome 'breathing space'.

Details are usually painted with small brushes, but this can sometimes result in a tight, overworked image. It is better to use a bigger brush which encourages a broader, freer approach. Provided it has a good point, a large brush can also be used for fine lines and details.

A simple dip pen with a steel nib is also an excellent tool for fine detail, and can be loaded with ink or watercolour. The strength and vivacity of the pen marks contrast well with the translucency of watercolour washes.

Detail work can be used to draw the viewer's eye to the focal point of a picture. More often than not this is placed in the foreground or middle distance.

Here, a small detailed area in the distance forms a counterpoint to the large restful areas in the foreground. This reversal of the normal practice of placing more detail in the foreground makes for a striking composition and gives the illusion of depth as the eye is drawn into the picture.

Pen work can be used to emphasise certain details in a composition. This contrast between broad washes and fine linear detail can be very effective in a watercolour painting.

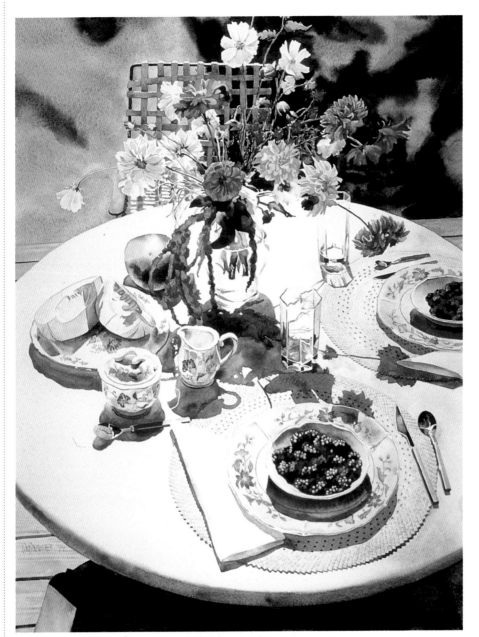

BLACKBERRIES AND COSMOS
WILLIAM C. WRIGHT

Here is an artist who takes great pleasure in observing objects in detail and in recording the way in which light falls on them. A detailed picture like this might take many hours to complete, but it shows what can be achieved with the watercolour medium. This technique involves a great deal of careful drawing and brush control and illustrates a high degree of skill and craftsmanship.

Although the composition of this still-life appears refreshingly natural, it was probably planned with great care. Imagine how quickly the composition would change simply by moving around the table by a few degrees. The bowl of blackberries in the foreground becomes the focal point because it is slightly separated from the other objects on the table, yet it is linked to them by the strong shadow shape which overlaps onto the plate. The sharply detailed highlights on the blackberries help to concentrate the eye on this focal point.

To achieve the crispness and clarity of detail he required, the artist has employed the tonal layering technique of working progressively from the lightest to the darkest values. The colours were applied to dry paper, which 'holds' the paint so that it dries with a crisp edge, and each colour layer was allowed to dry before the next was applied.

When depicting detail of this nature it is often necessary to use touches of body colour for the highlights because working around tiny areas of white paper would be too complicated. Most artists use white gouache paint for this purpose as it can be used thickly for an opaque covering, or diluted for a more a semi-transparent effect.

Masking Out Details

IN THIS LANDSCAPE scene the artist wanted to depict the small bright highlights by using the reflective qualities of the white paper. Attempting to paint around small, intricate shapes can be tricky, so the artist temporarily sealed off the white areas with masking fluid (see page 20).

Using a photograph as reference, she began by making a tonal sketch in soft pencil. This helped her to get to know the subject and to work out an effective composition. She was careful to plan the arrangement of light and dark values, which are so important in capturing the effect of light and weather on the landscape.

Materials

Sheet of 410gsm (200lb) cold-pressed watercolour paper • Watercolours: cobalt blue, burnt umber, new gamboge, raw sienna, indigo • Brushes: nos. 1, 3 and 6 • Masking fluid

Tonal Sketch

Masking out the lights

Make a light outline sketch in pencil to position the main shapes. Use masking fluid to fill in the shapes of the sheep and to 'draw' the lines of the wire fencing. It is a good idea to keep a small synthetic brush specially for this purpose, to save wear and tear on your best painting brushes. Allow the masking fluid to dry, and wash your brush immediately.

STAGE ONE
masking fluid

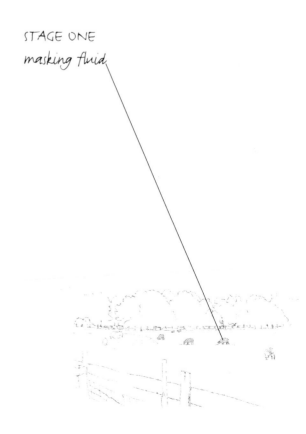

The background wash

Mix a thin, transparent wash of pale, cool blue. Loosely wash this over the sky and the silhouette of the trees with a no. 6 brush. This blue underwash will show through the greens applied later to the trees, helping to push them back into the distance (you may have noticed how greens near the horizon appear cooler and bluer than those close to you).

The foreground wash

When the blue wash is dry, mix a warm, sunny yellow and brush this over the field in the foreground. Because the sheep have been masked off you can paint right over them. Notice how the artist has worked loosely; this gives a more lively effect than a flat wash of colour.

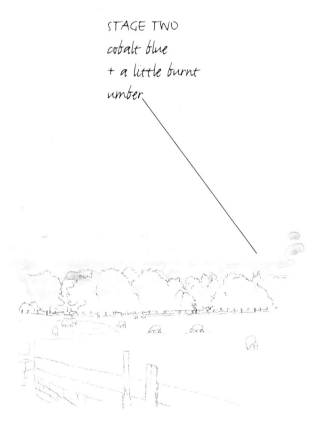

STAGE TWO
cobalt blue
+ a little burnt
umber

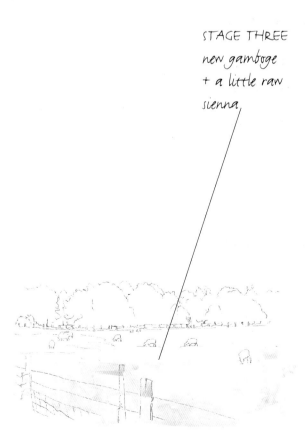

STAGE THREE
new gamboge
+ a little raw
sienna

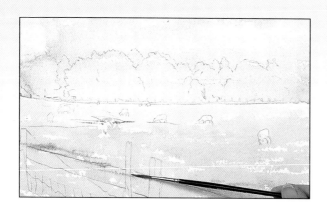

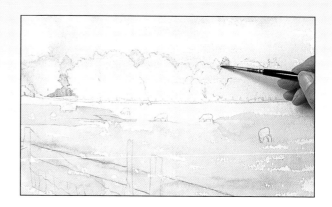

Adding cast shadows

Just before the yellow wash dries, brush in some cast shadows to add interest to the foreground. These shadows are mixed from blue and yellow (see below); use a greater proportion of yellow in your mix to create warm shadows and add more blue to create cooler, darker shadows. Because the shadows are applied wet into wet they dry with a soft edge, giving a natural effect.

STAGE FOUR
new gamboge
+ indigo

The distant trees

Now mix a stronger, darker version of the colour used in stage two and block in the more distant trees using the no. 3 brush. This helps to give the effect of a three-dimensional group of trees, with some farther back than others, rather than just a flat, boring line of trees. Almost any blue and brown mixed together will make grey. It is a useful colour for suggesting distance.

STAGE FIVE
cobalt blue
+ burnt umber

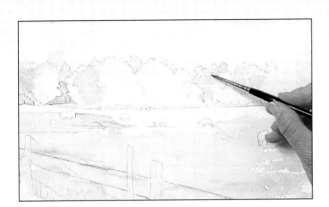

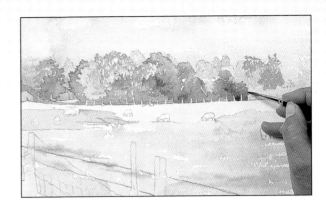

Adding warm highlights

The sun is to the left of the scene, so the left-hand side of each tree is lit with a warm glow. To capture this, paint these areas with a wash of bright, warm yellow using the no. 3 brush. Yellows will always add sunshine to your paintings and bring landscapes to life.

Adding cool greens

The shadow sides of the trees, facing away from the sun, are correspondingly cool in hue. Paint these middle-value areas with a blueish green. Try to vary the weight and density of colour to suggest clumps of foliage (see below). Notice how the artist has left small flecks of paper untouched in places to suggest the sparkle of sunshine on the leaves.

STAGE SIX
new gamboge

STAGE SEVEN
*new gamboge
+ cobalt blue*

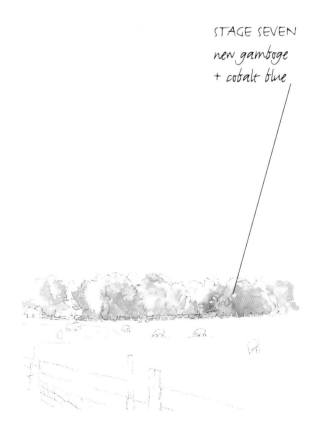

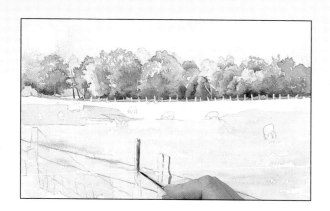

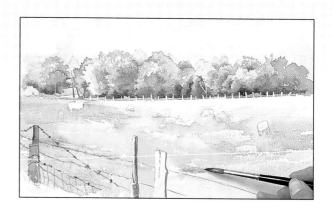

Painting the shadows

Just before the cool middle-value greens have dried, paint the dark shadows under the trees with a deep grey mixed from blue and brown. The trees are now complete, and you can see how the contrast of warm and cool greens effectively models their three-dimensional forms and creates the effect of light coming from the left. Switch to the no. 1 brush and use the same grey mix to paint the wire fencing and the shadow side of the fence posts.

Darkening the foreground

Using the no. 6 brush, overlay further washes of warm, middle-value green in the foreground, working carefully around the fence posts. Vary the strength of the washes to suggest the bumps and hollows in the land and to help to break up the expanse of the foreground.

STAGE EIGHT
indigo
+ burnt umber

STAGE NINE
cobalt blue
+ new gamboge

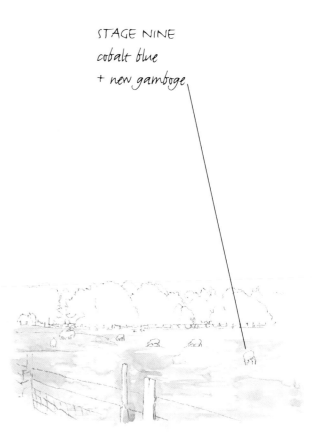

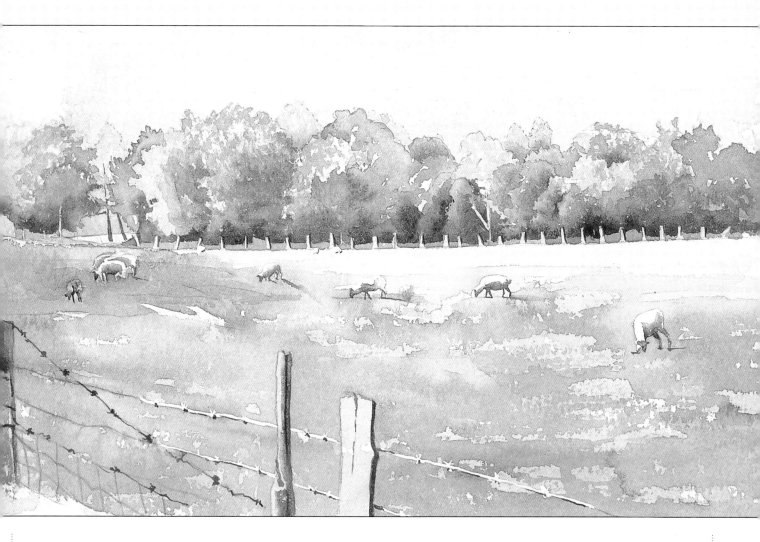

STAGE TEN
indigo
+ burnt umber

Allow the painting to dry completely. Now rub off all the masking fluid, using either your fingertip or the corner of an eraser, to reveal the white shapes of the sheep and the wire fencing. Mix a dark grey and use this to touch in the undersides of the sheep, as well as their heads and legs, with the no. 1 brush. Paint their cast shadows, too, softening the edges with a little water. Finally, add a few shadows on the wire fencing to complete the painting.

Wash and Line

CHURCHES AND CATHEDRALS are fascinating subjects, full of intricate detail. The problem is knowing how much detail to include in your painting without overworking it, and a preliminary sketch like the one below can be a useful start.

The trick is to resolve the building into its basic shapes first and add the decoration later. In this study of a cathedral doorway the artist has used broad watercolour washes to suggest the structure and bulk of the magnificent building, while delicate pen lines provide structure and detail. Both the watercolour and the pen detailing are worked quickly so as to catch the spirit of the subject without actually copying it detail for detail.

Materials

Sheet of 410gsm (200lb) cold-pressed watercolour paper • Pencil • Watercolours: new gamboge, cadmium lemon, yellow ochre, French ultramarine, warm sepia, permanent mauve, Payne's grey, raw umber, Indian red, cobalt green, sepia • Brushes: 18mm (¾in) and 10mm (⅜in) flats, no. 4 round • Dip pen

Tonal Sketch

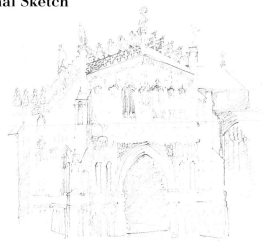

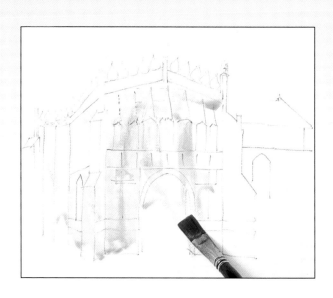

Lay the underwash

Draw the outline of the cathedral and some of the detailing. Mix the colours listed below and dilute to make a thin wash. Brush this broadly and loosely over the building using the 18mm (¾in) flat brush, leaving patches of paper untouched. This first wash gives a warm glow to the stonework.

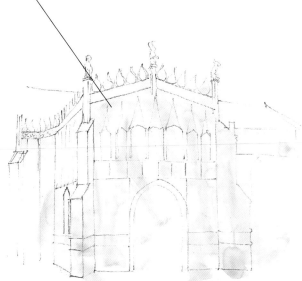

STAGE ONE
new gamboge
+ cadmium
lemon + yellow
ochre

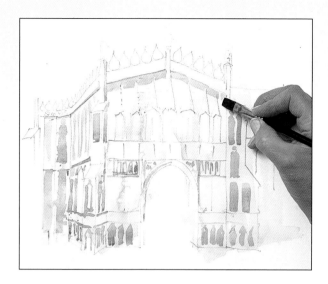

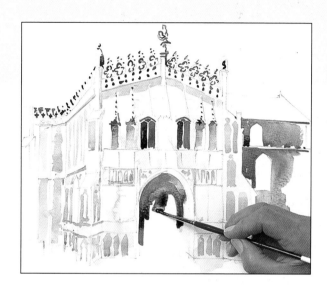

Add the mid tones

Mix a blue-grey wash and put in the middle-value areas – the windows, doors and the shadows cast onto the walls by overhanging masonry. Use the chisel edge of the 10mm (⅜in) flat brush for this, and don't attempt to fill in the shapes neatly; the effect is more natural when sketchily done. Allow the painting to dry.

STAGE TWO
French ultramarine + warm sepia + permanent mauve + Payne's grey

Put in the darks

Use the no. 4 round brush to pick out the shapes of the windows and the intricate stonework along the top of the wall with a darker grey. Vary the tones by adding more water in places to suggest the play of light. Use the 10mm (⅜in) flat brush to block in the farther walls and the doorway, this time adding more brown, plus some blue, to the wash (see below). Mix the colours loosely on the paper, wet into wet.

STAGE THREE
Payne's grey + raw umber

French ultramarine + Payne's grey + raw umber

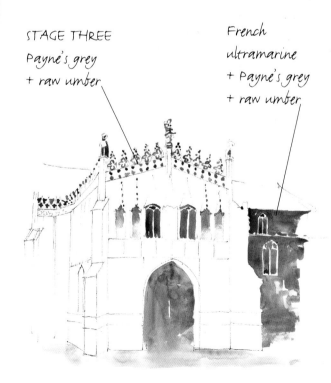

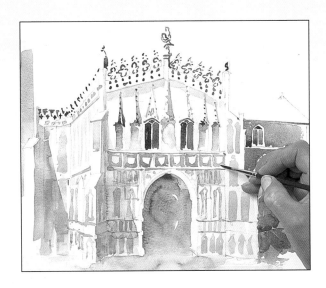

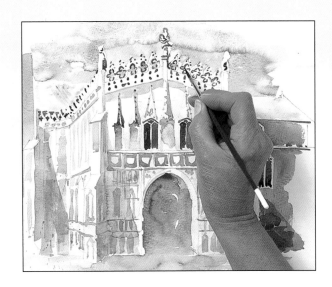

Add some warmth

Continue adding further cast shadows on the walls with a yellowish grey, then leave the painting to dry. Now you can pick out the detailing on the front of the cathedral using warm earth tones, applied with the no. 4 round brush.

The sky and the roof

Block in the roof with a cool, blueish green. Then paint the sky with a wash of pale blue, working the brush in different directions so that it doesn't appear too flat. Suggest the sky peeking through the decorative tracery along the roofline, too.

STAGE FOUR
Payne's grey
+ yellow ochre

Indian red
+ yellow ochre

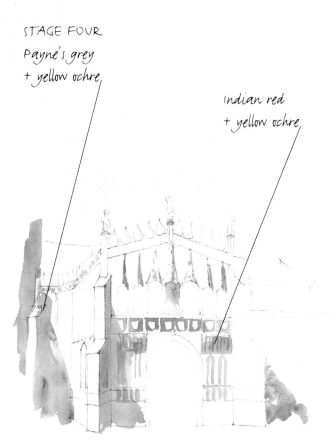

STAGE FIVE
French
ultramarine

cobalt green
+ French
ultramarine

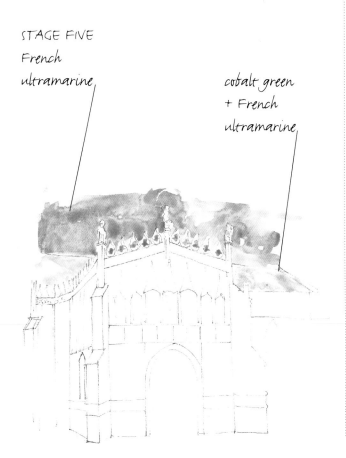

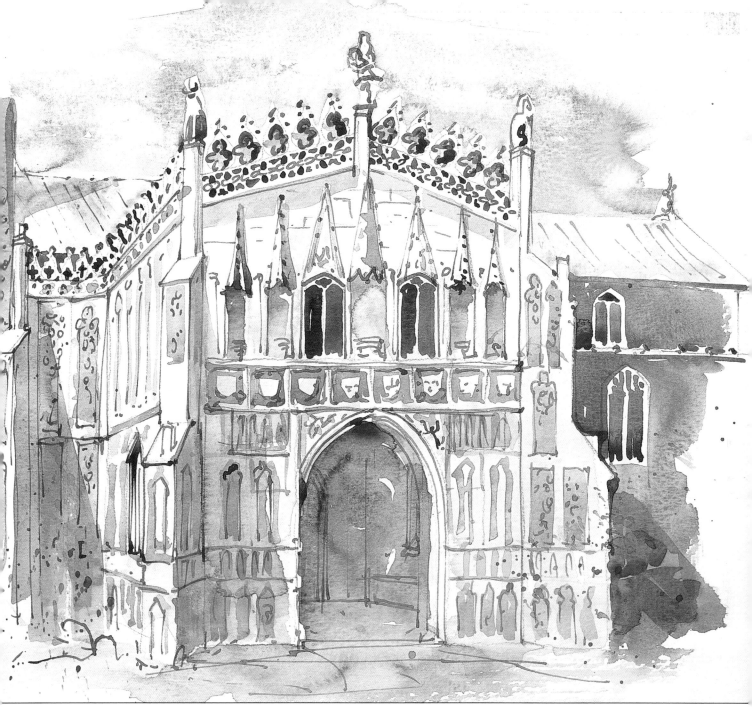

STAGE SIX
Payne's grey
+ raw umber
+ sepia

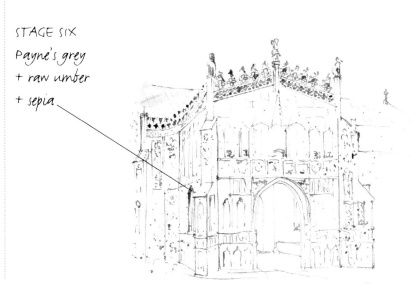

CATHEDRAL DOORWAY
KAY OHSTEN

*Once the painting is dry you can add the
final linear details using a dip pen. Use the
colours listed left, varying from grey to
brown. Scoop the paint onto the pen nib
with a paintbrush. Keep your pen work
lively, using the pencil lines only as rough
guides. Finally, suggest crumbling masonry
by lightly spattering some paint over the
front walls.*

Painting Detail

THESE TWO ARTISTS have used carefully observed detail to produce arresting images.

Both demonstrate careful preplanning and drawing together with skill in handling the medium. The two paintings convey a very different atmosphere, however, one expressing life and movement, and the other strength and solidity.

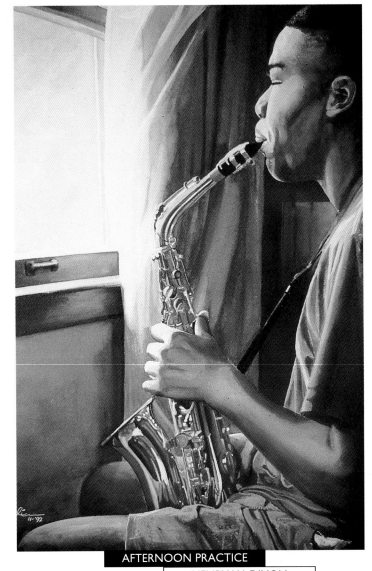

AFTERNOON PRACTICE
HENRY W. DIXON

Working order

Here the artist describes the idea behind the painting. In this simple but intricate painting there are two focal points, of which the dominant is the saxophone while the figure is the subordinate.

1 After making a careful drawing, the artist started with the lightest values, applying very pale washes over the sunlit windowsill, the hand, face, curtain and parts of the saxophone.

2 Mixtures of alizarin crimson, Hooker's green, and cadmium yellow were used to create the variations in the skin tones. To give the curtain a more transparent and luminous appearance, a damp cotton swab was used to lift out some colour in the folds.

3 At this stage the artist concentrated on the details of the saxophone, making sure each shape and value was accurately captured. Mixtures of cadmium yellow and emerald green were mixed and used as a dominant colour to depict light and shade on the brass instrument.

4 After lifting off colour from the right side of the curtain, a wash of Hooker's green and cobalt blue was applied to depict reflected light and colour from the young man's shirt.

5 Finally the dark shadow areas were painted in using alizarin crimson and Prussian green, thereby strengthening the tonal structure.

Key Planning Points

• Plan the dark areas carefully, as these will enhance the lightest points. A detailed pencil sketch was made showing all reflection shapes, and the values were sketched in for the figure and clothing

• Do not be afraid to wash colour off, either using a stiff brush, rag or sponge

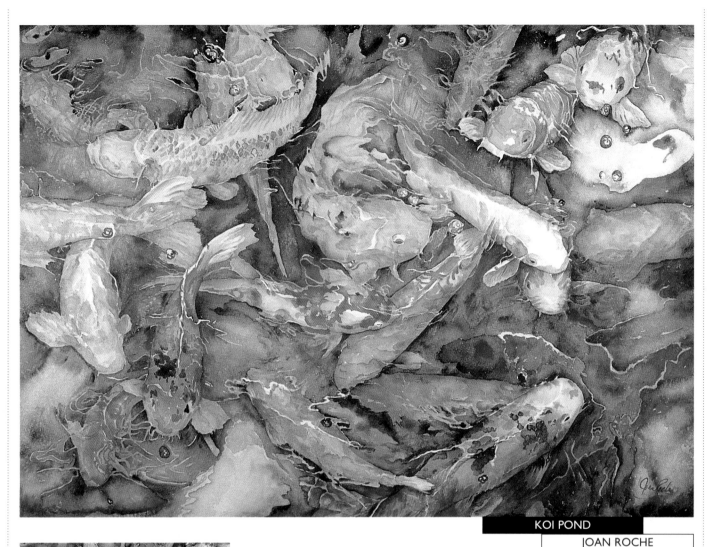

KOI POND

JOAN ROCHE

Working order

The artist took photographs as a starting point, then assembled the elements into a composition which emphasises movement and space by overlapping and 'knocking back' some of the shapes, creating a pattern for the eye to follow.

1 First the design was drawn in, and then the reflections on the bubbles and the ripples in the water and on the surface of the fish were masked out.

2 After the masking fluid had dried, a warm orange made up from cadmium scarlet and Winsor yellow was applied over the whole surface.

3 A thin wash of ultramarine and a touch of cadmium scarlet was applied to the shadow areas on the fish, following the pattern of the ripples so that the colour becomes darker in the areas further away (deeper in the water).

4 Movement, light and ripples were created by a wet into wet mix of ultramarine, viridian, cobalt blue and sepia. The masking fluid was then removed and the darker areas built up with successive glazes, taking care to leave the light reflections.

5 The same method was used on the fish, using combinations of Winsor yellow, cadmium orange, cadmium scarlet, raw sienna and sepia.

6 Working wet into wet, sap green, ultramarine and a little raw sienna were applied to the lily pads.

Key Planning Points

- For subjects that cannot easily be painted from life, assemble compositions from reference material
- For complex subjects, make sure the drawing is right before you paint

Painting Atmosphere

Watercolour has many attributes – fluidity, transparency, delicacy of colour – that make it ideal for reproducing the effects of atmosphere and weather on the landscape. Whether you are depicting mountains shrouded in mist, a stormy seascape or a beach scene in high summer, watercolours can provide you with a wide range of atmospheric effects.

CUMBRIAN COTTAGE
ALAN OLIVER

In this painting I set out to capture the atmosphere of early morning light in the autumn. The sun streams across from the left of the picture, spotlighting the end wall of the house. The long shadows in the foreground are pale and cool, suggestive of low morning sun. A strong element in this composition is the gate. The rich dark behind it has been exaggerated so that it shows up light against dark.

W HEN WE FIRST learn to paint we tend to concentrate on the basic issues of representation: 'how to paint trees' or 'how to paint clouds'. But as you gain more experience you should start to think not just about the objects in the landscape but also about the quality of the light on the scene. Light is the magic ingredient that can turn a mundane painting into something much more special.

If at all possible, try to paint landscapes on location rather than from photographs. Even if you haven't time to complete a painting on location, you can always make sketches to use as a reference when you get back home. There is no substitute for being on the spot, alive to the sights, sounds and smells of your subject.

Before you start to paint, try to assess the special quality of the light, which is affected not only by the time of day but also by the season and the weather. On a bright sunny day the light is clear and sharp, with strong contrasts of light and shadow and bright, saturated colours. Fog and mist

Brilliant white indicates direction of light source

Long shadows create a feeling of low, early morning sun

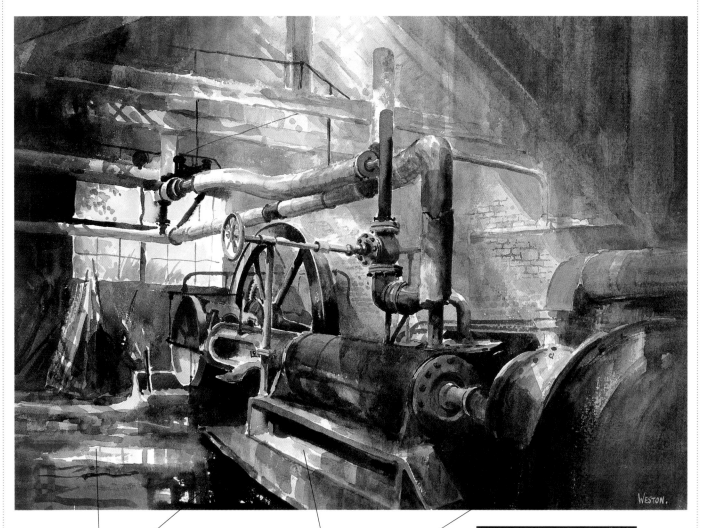

Puddles indicate neglect and a damp atmosphere

Brilliant lights against rich darks

RUSTING STEAM
DAVID WESTON

There is just enough detail in this painting to depict the subject clearly, but the picture is really about atmosphere and nostalgia for past glories. Strong sunlight is cutting through holes in the roof, brilliantly illuminating various parts of the old engine and leaving the rest of it in deep shadow. The puddles of water on the floor add to the poignant sense of neglect and decay.

soften the landscape and reduce contrasts of colour and tonal value. In the early morning a scene is often bathed in a cool, soft, pinkish light and the low sun casts long shadows across the landscape. In the late afternoon and evening, again the shadows are long but the light is usually much warmer. Similarly, there is a difference between the cool, soft light of spring and the stronger, warmer light of summer.

Colour itself can help to convey the particular mood or time of day you wish to portray. By choosing a limited range of colours you can give your paintings a strong atmospheric feel. For example, cool blues, violets and greens will underline the dramatic tension of a stormy day or a cold winter evening. Warm reds and yellows will evoke heat and sunshine, or the peaceful calm of the sunset hour.

Think also about how you can use watercolour techniques to portray atmospheric conditions. The most obvious example is the use of wet washes to suggest clouds, rain and mist. You can also try lifting out colour with a soft sponge or rag to create soft effects. In contrast, the effect of bright sunshine is often captured by using crisp, hard-edged strokes applied wet over dry.

Adding Drama with Darks

IT IS TEMPTING to paint only on sunny days, but it is worth bearing in mind that even the dullest winter day can have plenty of painting potential. This is amply demonstrated in this beach scene, in which the foreground elements are starkly silhouetted against a stormy sky. It is this drama of dark against light which gives the painting its impact.

The artist began by making a preliminary pencil sketch, concentrating mainly on the boats, tractor and breakwater. By first getting to know the form and details of these objects, he was able to paint them with greater confidence.

Materials

Sheet of 410gsm (200lb) cold-pressed watercolour paper • Pencil • Watercolours: French ultramarine, neutral tint, yellow ochre, raw sienna, permanent mauve, Prussian blue, cadmium red, permanent rose, burnt sienna • Brushes: nos. 24, 14 and 4 round

Tonal Sketch

Paint the sky

Lightly sketch in the main outlines of the composition. Mix a blueish grey for the sky (see below). Dampen the sky area with clean water, then load the no. 24 brush with plenty of colour and sweep it across the paper. The washes will flow gently downwards on the damp paper, softly diffusing to give the effect of mist and rain. Let the colour fade out towards the right of the picture to indicate the sun breaking through the clouds.

STAGE ONE
French
ultramarine
+ neutral tint
+ yellow ochre

The background

Having set the atmosphere of the scene by painting the sky, continue by working from the background to the foreground. First block in the distant cliffs and beach with a greyish yellow (see below), then use the tip of the brush to indicate the distant sea.

The focal point

The boat and wooden breakwater which form the focal point of the picture are positioned in the middle ground. Paint the breakwater with a warm grey, leaving the highlights on the posts untouched (see below). Then wash over the boat hull and the trailer with blues and greys.

STAGE TWO
French
ultramarine
+ a little
neutral tint

raw sienna
+ permanent
mauve

STAGE THREE
neutral tint
+ French
ultramarine
+ yellow ochre

Prussian blue
+ raw sienna

neutral tint
+ French
ultramarine

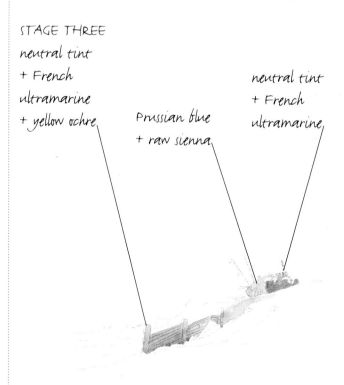

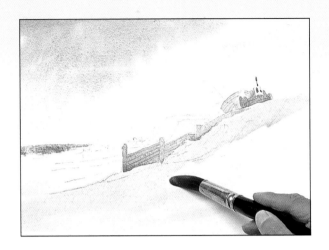
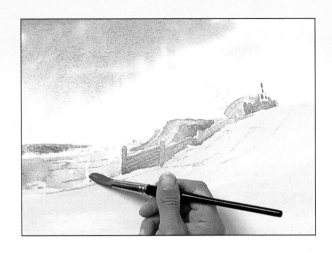

The foreground

Now you can move on to the foreground. Paint the sandy beach with bold sweeps of colour, loading your brush with plenty of paint. This yellowish tone will form the underlayer for the further washes to come. The basic elements of the scene are now established.

Strengthen the tones

Switch to the no. 14 brush now and strengthen the tones on the cliffs in the middle distance using the colours listed below. Notice that the nearer cliff is darker than the farther ones, thus creating the illusion of receding space. Darken the value of the sand in the middle distance. Use a semi-dry brush to lift off some of the wet colour to indicate reflections on the wet sand.

STAGE FOUR
raw sienna

STAGE FIVE
yellow ochre
+ neutral tint
+ French
ultramarine

raw sienna
+ French
ultramarine
+ neutral tint

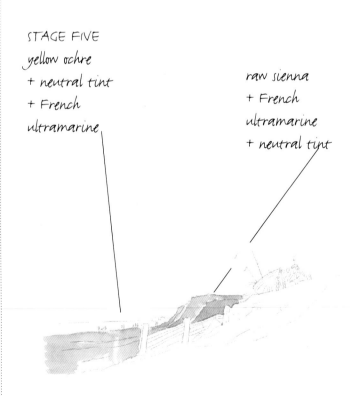

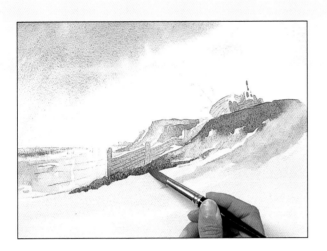

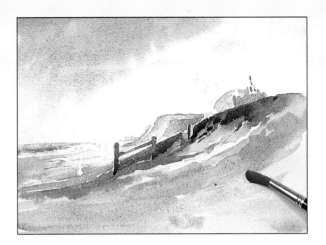

Work on the foreground

Mix up various earth colours (see below) to strengthen the foreground and help bring it forward. Use a wet-in-wet technique, letting the colours blend into each other, to suggest the bumps and hollows in the sand dunes. Brush a little earth colour over the distant sea, too; this softens the blue and thus pushes the sea farther back, increasing the sense of space.

Add more darks

Mix a rich, dark brown for the breakwater, leaving small patches of the first wash showing through. Continue this wash on up to the top of the foreground cliff. This dark area now forms a dramatic contrast with the lighter values elsewhere in the picture. Mix a warm grey and apply this over the sand in the immediate foreground.

STAGE SIX
raw sienna

neutral tint
+ raw sienna
+ burnt sienna

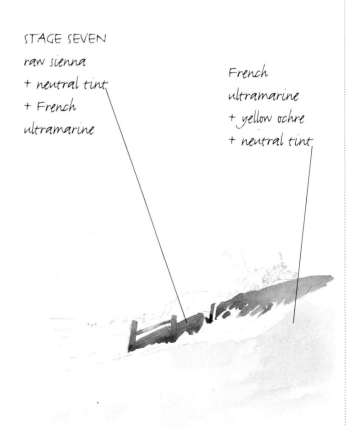

STAGE SEVEN
raw sienna
+ neutral tint
+ French
ultramarine

French
ultramarine
+ yellow ochre
+ neutral tint

Luminous Washes

IN THIS PAINTING I have tried to capture the effect of early morning light on that most atmospheric of cities, Venice. I began by soaking the paper and then applying variegated washes of pink and yellow – just a faint blush of colour suggesting the warmth of the rising sun pervading the scene. I worked wet in wet so that the colours would merge gently into each other and dry with a soft, hazy quality that evokes the slight mistiness of early morning light.

I then used the tonal layering technique, starting in the distance with the lightest values and working up gradually to the stronger values and details in the foreground. There is a stillness and quiet at this time of the day, which I have tried to express by keeping the composition simple and detail to a minimum.

Materials

Sheet of 410gsm (200lb) cold-pressed watercolour paper • Watercolours: French ultramarine, cerulean, Prussian blue, permanent rose, raw sienna, cadmium red • Brushes: nos. 6 and 16 round, large mop

Tonal Sketch

Variegated washes

Make a light pencil drawing of the scene. Mix a generous wash of soft pink and another of soft yellow. Using the large mop brush, wet the entire sheet of paper with water and allow it to soak in slightly. Load the brush with pink paint and sweep a couple of broad horizontal strokes across the top of the paper. Rinse the brush, load it with yellow paint and repeat the process. Finish with a broad stroke of pink at the bottom. Allow to dry.

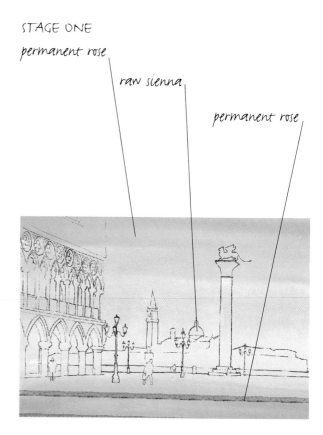

STAGE ONE
permanent rose

raw sienna

permanent rose

Add more cool shadows

Mix a fairly strong violet from blue and pink. Use the no. 6 brush to paint the inner recesses of the buildings and the shadows on the pillars. Vary the washes by adjusting the proportions of pink and blue and by adding more or less water. Paint the shadow on the column, softening the inner edge of the stroke to give an illusion of roundness. Paint the shadows in the foreground with sweeping strokes of the no. 16 brush. Block in the figure atop the column with a cool blue.

Add distant details

Strengthen the cool blue wash and add shadows to the figure to give it three-dimensional form. Now use the violet-blue wash, similarly strengthened, to suggest details such as the mooring poles along the water's edge. Here you can see how a large brush can be used to paint fine details as long as it comes to a good point.

STAGE SIX
French
ultramarine +
permanent rose

Prussian blue

STAGE SEVEN
Prussian blue

French
ultramarine +
permanent rose

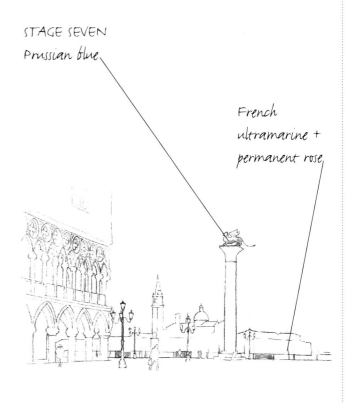

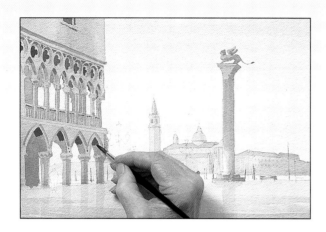

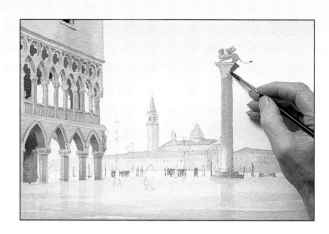

Darken the shadows

The darkest shadows in the recesses of the main building can now be strengthened with further washes of violet-blue. This time make the colour warmer by adding more pink and less blue. When painting the arches, grade with wash from dark at the top to light at the bottom.

Add foreground darks

Prepare a strong wash of red and blue and paint in the really dark shadows behind the arches of the main building. Again, grade the washes by lifting out some of the colour to suggest the play of light. Add a final dark shadow down the outer edge of the column.

STAGE EIGHT
permanent rose
+ French
ultramarine

STAGE NINE
Prussian blue +
cadmium red

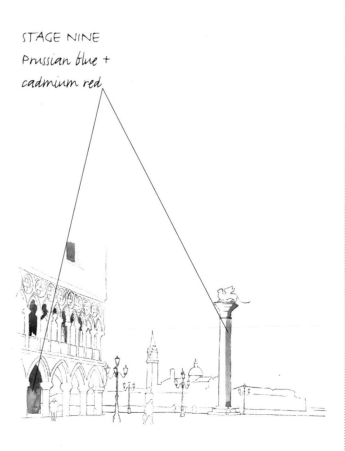

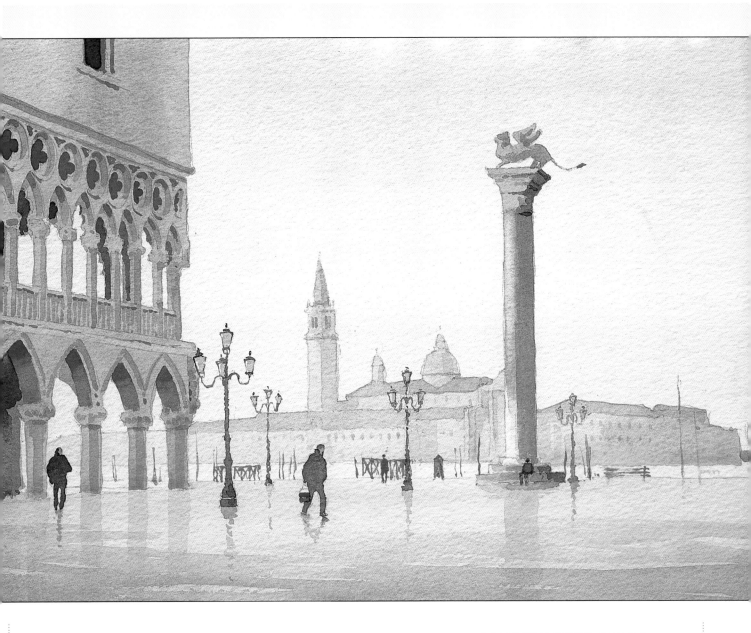

STAGE TEN
Prussian blue +
cadmium red

French
ultramarine

cadmium red

cadmium red

VENICE, EARLY MORNING
ALAN OLIVER

Mix a very pale red and paint the glass lamps and the faces of the nearest figures. Now mix a cool grey from blue with a touch of red and complete the nearest figures and their reflections. Use the same colour to paint the lamp posts, making them lighter in value the further distant they are to aid the feeling of recession. Finally, add a few spots of pure red and blue to the figures to add a note of contrast.

Painting Atmosphere

BOTH OF THESE PAINTINGS are successful recreations of the effects of light, achieved by clever control of tonal values and the use of pre-planned simple colour schemes. Both artists have given a great deal of thought to creating a particular impression rather than focusing too much on details. The layering (or glazing) technique is used by both painters to build up rich colours, but the techniques differ, with the crisp shapes in 'Sunburst' created by working wet on dry, and the soft blends in 'Sedona Sunset' achieved by merging colours wet in wet.

SEDONA SUNSET

DONALD HOLDEN

Working order

Working on location, the artist made a series of small, quick sketches defining the main shapes of land and sea, and back in the studio he made another series of drawings to reorganise and simplify the design. He chose a palette of colours that suited the subject – ultramarine, yellow ochre, permanent rose and brown madder – and began to paint directly, with no pencil line.

1 A yellow ochre wash was applied over the whole paper as an even tone.

2 A graded wash of ultramarine was then applied from the top, fading to clear water about a third of the way down. Another graded wash of permanent rose was then painted from the bottom up, leaving a band of yellow ochre in the middle for background atmosphere.

3 Using a mix of permanent rose and brown madder, the mountain shape was painted in, and while these areas were still wet, blue shadows were added so that the colours merged wet into wet.

4 The mid-sky area was moistened with an atomiser and left until it lost its shine before the low-lying strips of cloud and distant land were painted in with pale washes of ultramarine.

5 To warm and unify the painting, the entire sheet was then covered with a pale wash of permanent rose. While this was still wet, darker ultramarine was used to produce the cloud shapes.

6 When dry, a pale wash of yellow ochre was applied over the whole surface. To create the sunset effect, permanent rose was worked in to the wet paint.

Key Planning Points

• Visualise the colours of the light that pervades the whole subject, and choose the paint colours carefully
• Plan the first series of washes in advance and, unless working wet into wet, make sure each wash is totally dry before adding another

SUNBURST

JUDI BETTS

Working order

The artist was inspired by the pattern of shadows and light on this house on a hot, humid summer day. She has stressed the lighting conditions by choosing a palette of warm colours and retaining a very high-value key throughout the painting. The main colours were rose madder, aureolin, burnt sienna and cadmium orange, with the cool colours – Winsor green, Winsor emerald, manganese blue and cobalt blue – used sparingly.

1 A pale background wash of aureolin over the whole surface established the lightest areas.

2 A series of middle value washes was laid next, building up to as many as five layers in some places, all taken carefully around the light areas. Each colour was allowed to dry before applying the next.

3 The darkest areas, the shadows on the steps and under the stairway and balcony, were then added to complete the tonal range.

4 In places, small areas were lifted out with a wet sponge, using a template of thin card cut to the required shape. Some of these shapes were painted over with pale greens to indicate foliage.

Key Planning Points

- To assess the values in a subject, remember to half-close your eyes, which helps to cut out detail and shows you the broad shapes
- Decide on the right format for the composition. Here the horizontal format emphasises the diagonal thrust of the stairway

Painting Shadows

Shadows are an aspect of painting that is overlooked, something to be tacked on at the end of a painting without much thought. Yet shadows are a vital part of any painting, whatever the subject. Not only do they help to define the forms of objects, they also indicate the direction of the light and can even enliven a composition.

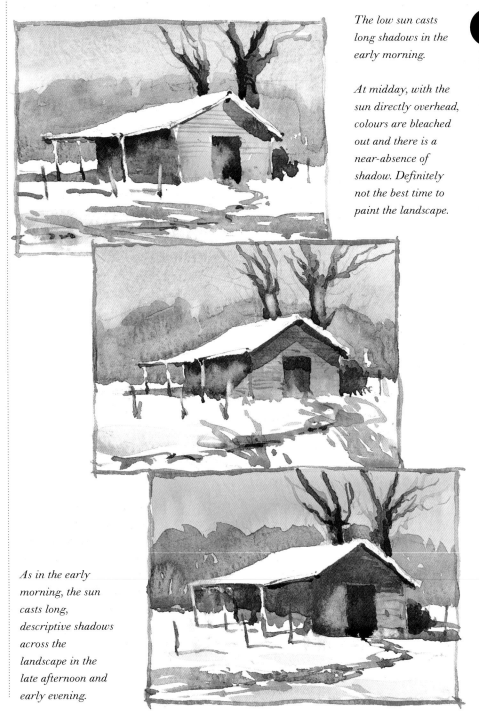

The low sun casts long shadows in the early morning.

At midday, with the sun directly overhead, colours are bleached out and there is a near-absence of shadow. Definitely not the best time to paint the landscape.

As in the early morning, the sun casts long, descriptive shadows across the landscape in the late afternoon and early evening.

SHADOWS AND CAST shadows will be present in virtually every subject you paint; even on a dull day the sky will provide some light, therefore there will be shadows and cast shadows on the landscape, albeit very pale and diffuse. Look at any object in your room and you will notice that it has a light side and a dark side, caused by light coming in through a window or from a nearby lamp. It will also be casting a shadow onto the surface beneath it.

These shadows help to define the shapes and textures of the objects they fall across.

There is more to shadows than meets the eye, and they make a fascinating area of study. For instance, if you look carefully you will see that shadows are not grey or black but actually contain subtle nuances of colour picked up from their surroundings or from the surfaces they fall on. Observe how the shadow areas are always cooler in colour than those exposed to bright, warm light. On a bright sunny day you might have noticed how shadows take on a blueish or even violet hue. The reason is that there is a lot of ultraviolet light present, and this is reflected in the shadows. Because the light is so bright it 'bounces' from one surface to another. For example, if you look at the shadow on a wall you will notice that it is lighter at the base where light from the ground is bouncing up into it. Observing and recording these subtle effects will give sparkle and luminosity to your paintings.

GARDEN SEAT
ALAN OLIVER

In both of these paintings I have used cast shadows to indicate the light source and to describe the contours of the landscape. In 'The Garden Seat' light and shadow give roundness to the tree trunks and the low angle of the sun is suggested by the shadows on the seat. Without the shadows, there would be no feeling of sunshine and much of the atmosphere would be lost.

In 'A Country Lane' the shadows once again indicate the direction of the light and suggest the time of day. The long foreground shadows emphasise the contours of the land and encourage the eye to move across and around the picture.

In both paintings the shadow washes consist of a thin, transparent mixture of French ultramarine and alizarin crimson. These shadow washes were added at the last stage, when the paintings were completely dry. Provided the wash is thin enough, the underlying colours show through the shadow wash and the result is airy and luminous. The underlying colours are not disturbed so long as you apply the shadow wash quickly, in one go, using a large, soft brush.

A COUNTRY LANE
ALAN OLIVER

Shadows are useful in indicating the time of day and the type of weather conditions, and can therefore add much to the mood and atmosphere of your paintings. Early morning and late afternoon are the best times to paint because at these times the sun casts long shadows full of interesting colour. Before you start painting, always establish the direction of the light source and indicate the shadow areas on your paper from the outset. That way, as the day progresses and the sun changes position, you won't end up with shadows cast in confusingly different directions!

Another point worth noting is that shadows can contribute to the design of a picture by linking one area with another. Look out for the counter-change of light objects against a darker background and dark objects against a lighter background.

Watercolour is a wonderful medium for painting shadows because the colours are transparent. This means that you can paint cool shadow washes over previously painted warm colours, allowing some of that warmth to glow up through the shadow. The result is a luminous shadow that seems to vibrate with light. You must apply the shadow wash quickly and lightly, though, so as not to disturb the underlying wash.

Contrasts of Warm and Cool

TO PAINT PICTURES filled with sunlight you must understand the importance of shadows, because it is the contrast between cool, dark colours and the warm, bright hues that creates the sparkle.

When composing a sunlit scene, remember that either the bright, warm areas should dominate, or the cool, dark shadows. If there is an even spread of lights and darks, the effect of dazzling sunshine is lost. In this view of an old French town, for example, dark and middle values predominate, yet the overall impression is of a sunny afternoon because the sunlit areas really sing out against the dark, contrasting passages of shadow.

Materials

Sheet of 410gsm (200lb) cold-pressed watercolour paper • Pencil • Watercolours: permanent mauve, French ultramarine, light red, raw sienna, new gamboge, burnt sienna, cobalt blue, permanent rose, Indian yellow, cerulean, cadmium red • Brushes: 25mm (1in) flat, nos. 14 and 2 round

Tonal Sketch

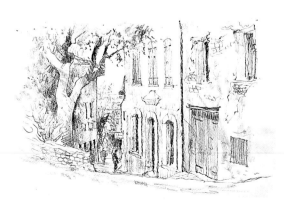

The background tint

Lightly sketch the main elements of the scene, checking that the perspective of the doors and windows is correct. Mix puddles of warm yellow and cool blue (see below) on your palette and dilute with plenty of water. Use the 25mm (1in) flat brush to apply the yellows over the sunny parts of the scene, and the blues over the shadow areas. Leave this background tint to dry.

STAGE ONE
permanent mauve + French ultramarine + light red raw sienna new gamboge burnt sienna

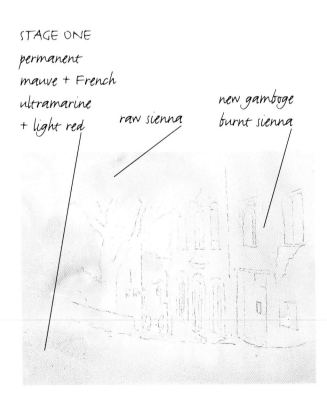

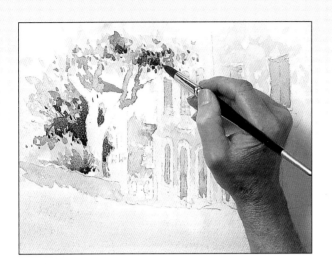

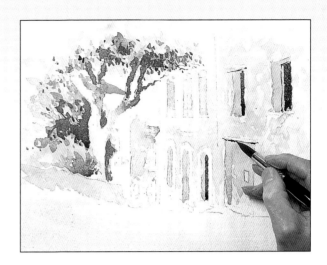

Adjust the values

Add a third wash of dark, cool green to the tree to deepen the shadows even further. Vary the tonal value of the wash by adding more or less water to the basic colour. Now mix a warm red-orange and use the no. 14 round brush to paint the terracotta roof glimpsed in the distance.

Add some darks

Now that most of the middle values are in place, it is time to touch in some rich darks for tonal contrast. The tonal sketch indicates dark tones in some of the window and door openings; paint these with the no. 14 round brush and a dark, cool brown, using the colours indicated below.

STAGE SIX
Indian yellow
+ French
ultramarine cadmium red
+ new gamboge

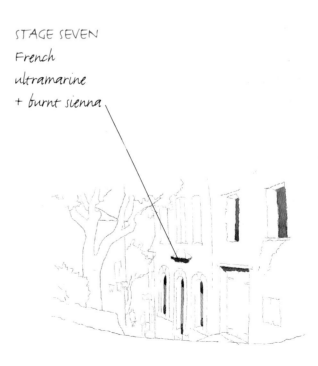

STAGE SEVEN
French
ultramarine
+ burnt sienna

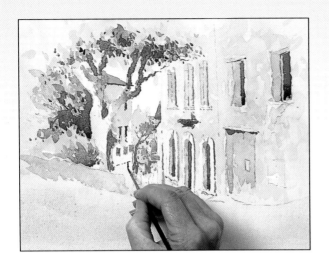

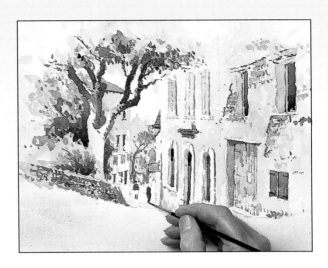

Start on the details

Having completed the broad washes you can begin to work on the smaller architectural details. Use the colours listed below, applied with the no. 2 round brush. Adding detail should always be done towards the end of the painting, and even then it should be kept to a minimum, otherwise it can render your painting fiddly and overworked. To achieve crisp, dark marks, gently squeeze out the brush to remove most of the water before picking up the colours.

Complete the details

Mix a dark grey-green to complete the shadows on the tree. Then use browns and grey-browns to suggest the crumbling stonework on the wall beneath the tree and on the house on the right. Finish painting the shadowy tones in the door and window openings. Complete the details by adding touches of colour to the figures in the background. Leave the painting to dry completely.

STAGE EIGHT
burnt sienna
+ French
ultramarine
+ cadmium red

French
ultramarine
+ permanent
rose

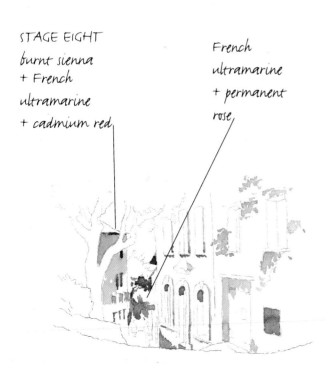

STAGE NINE
French
ultramarine +
Indian yellow

French
ultramarine +
permanent rose
+ burnt sienna
+ new gamboge

burnt sienna
+ light red
+ French
ultramarine

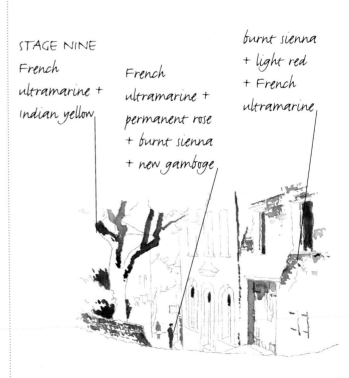

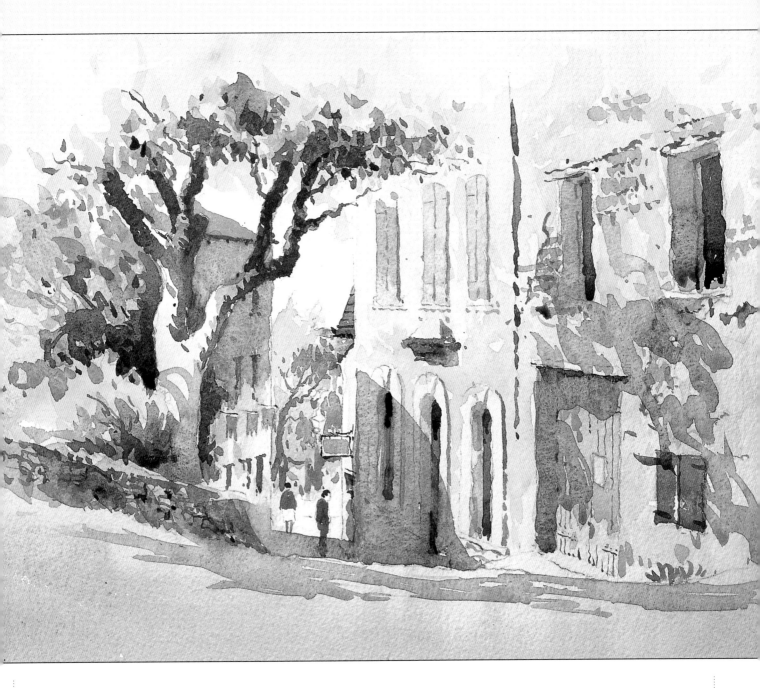

STAGE TEN
French
ultramarine
+ permanent
rose

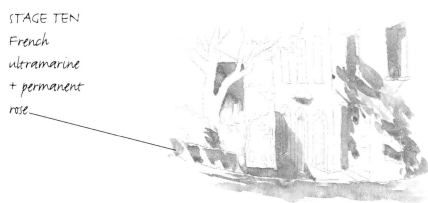

FRENCH STREET SCENE
ALAN OLIVER

The final touch is to apply the cast shadows that play across the street and the walls of the buildings. Mix the colours left to create a cool blue-purple. Dilute with plenty of water and sweep the transparent colour on quickly and lightly with the no. 14 round brush; any prolonged fiddling with the brush may disturb the colours underneath. Adding these shadows has a magical effect – suddenly the scene really springs to life.

A Limited Palette

WHAT INSPIRED THE artist to paint this dilapidated old barn interior was the bold pattern of light and shadow created by strong light flooding into the dark, enclosed space from the windows and skylights. The composition and value pattern were worked out in a fairly detailed preparatory drawing, which helped the artist to familiarise himself with what was a fairly complex subject. In the final painting, however, the interior was simplified in order to concentrate on the fundamental theme of light and shadow.

Materials

Sheet of 410gsm (200lb) cold-pressed watercolour paper • Pencil • Watercolours: light red, yellow ochre, sepia, Prussian blue, raw sienna, Indian red • Brushes: nos. 20 and 4 round

Tonal Sketch

Background tint

Lightly draw the composition, using your sketch as reference. Load the no. 20 brush with a wash of warm yellow (see below) and apply this over the whole drawing except for the skylights and the open doorway. Rinse the brush and squeeze it out between your fingers, then use it to gently lift out bands of colour to depict the light reflected on the wall from the high windows.

STAGE ONE
light red
+ yellow ochre

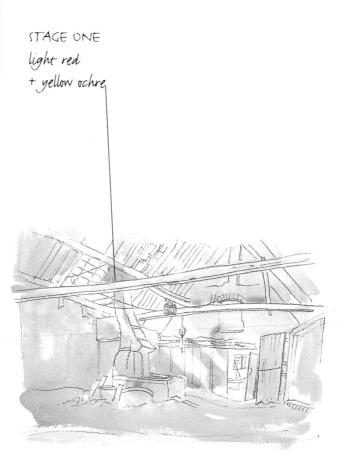

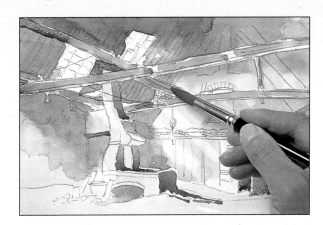

Paint the shadows

Use a wash of warm grey to darken the roof and the left-hand wall of the barn, working around the shapes of the skylights, the forge chimney and the wooden ceiling beams. Vary the weight of colour to give a sense of shifting light. Leave the painting to dry.

Build up the colours

Keep working around the picture, bringing the whole image on at once rather than concentrating on one area at a time. This will give your painting a unity and harmony. Mix up a warm brown and use this to paint the shadows on the brick forge and chimney. Then mix a greyish green and wash this over the doors, the beams and parts of the far wall.

STAGE TWO
sepia
+ Prussian blue

STAGE THREE
light red
+ sepia

Prussian blue
+ raw sienna

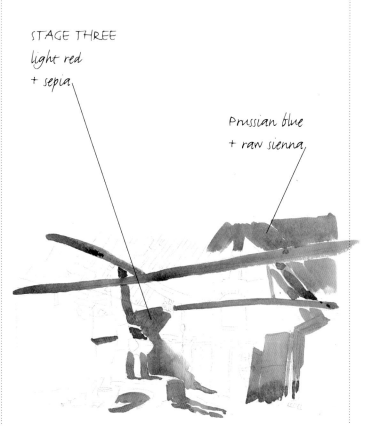

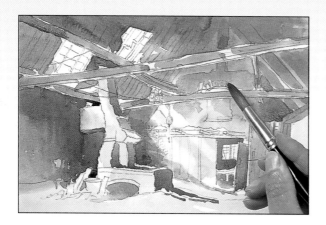

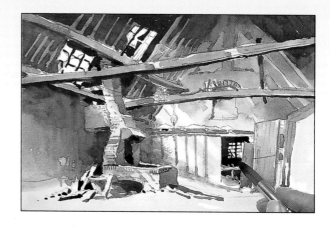

Intensify the shadows

Darken the interior walls with further washes of brick red and brown, using the colours listed below. Start to suggest the pattern of brickwork on the chimney. Add more grey to the mix for the deeper shadows and for the dark interior glimpsed through the open door on the right. This small area of dark value is essential to balance the whole painting. Allow the washes to dry.

Complete the darks

Rinse out your brush, then flick it over a clean rag to remove most of the water before dipping it into a fairly strong wash of grey for the final layer of rich darks. It is these very dark tonal values that make the lights look brighter by contrast.

STAGE FOUR
sepia
+ Indian red

STAGE FIVE
sepia

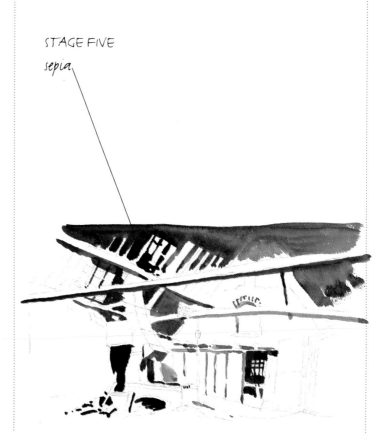

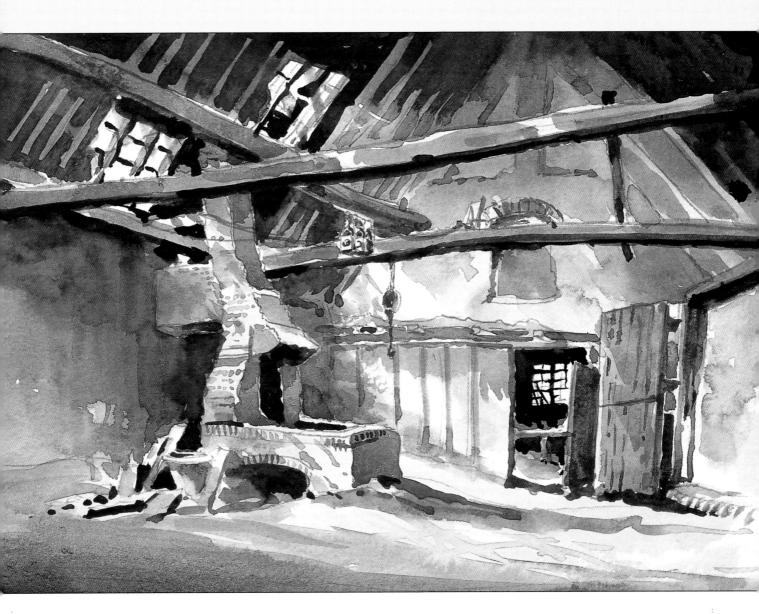

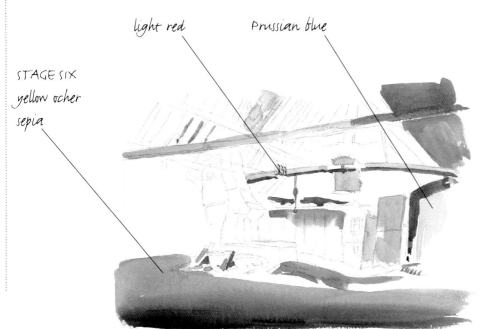

light red

Prussian blue

STAGE SIX
yellow ocher
sepia

THE OLD FORGE
DAVID WESTON

Apply a broad sweep of pale yellow across the foreground, then add a wash of grey over it, wet into wet. Use the same colours to add final touches of detail and local colour to the interior, plus a touch of pale blue on the right-hand door. Finally, use the no. 4 brush and light red to paint the lamps and the hook hanging from the beams.

Painting Shadows

IN BOTH THESE paintings, the strong shadows are fundamental in helping to produce brilliance of light, but in 'Cherry Bouquet with Ducks' the shadow also plays a vital compositional role. It is a strong element in the design, its shape linking the objects together, and its strong, cool colour contrasting with the warm pinks of the flowers. The depth of tone and brilliance of colour have been exaggerated slightly to heighten the complementary contrasts that make the painting sparkle.

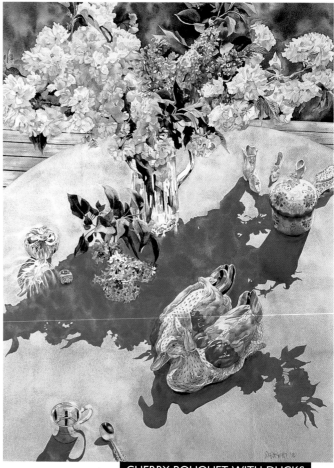

CHERRY BOUQUET WITH DUCKS
WILLIAM WRIGHT

Working order

The artist took time over building up an arrangement with strong lighting, and then photographed the subject. From the photograph he produced a careful pencil drawing, which he transferred onto watercolour paper using a grid. The colours used include cerulean, vermilion, raw sienna, burnt sienna, French ultramarine and cadmium yellow.

1 A pale mixture of cerulean and vermilion was used to make up a grey wash for the tablecloth area, painting around the objects.

2 A pale pink wash was used behind the flower heads, working wet into wet, and keeping the values light.

3 A wash of cerulean was painted around the flower heads, and a strong green was dropped in while the blue was still wet to form a dark background.

4 With the grey of the tablecloth now dry, the shadow shape was painted with a mix of cerulean and French ultramarine.

5 In the final stages, concentrated pigments were used to brighten the colours and to give continuity. The gold duck bills were painted with cadmium yellow deep, vermilion and raw sienna, colours which are repeated in the shoes, the ring and the reflections on the silver and glassware.

Key Planning Points

- Choose a collection of interesting objects to arrange into a still-life subject. Use your viewfinder to consider the composition
- Ensure a bright light source to produce strong shadow shapes
- Use the shadows as part of the composition, and take care observing their shapes

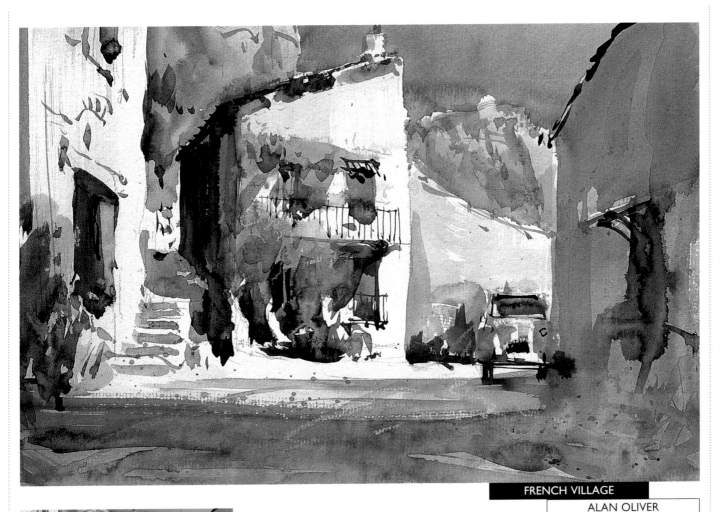

FRENCH VILLAGE

ALAN OLIVER

Working order

The strong light, producing dark contrasting shadows, was the obvious inspiration for this painting, loosely based on a photograph. Although the style is loose and painterly, there is just enough detail to add interest and realism. A tonal sketch was made to plan the painting and a restricted palette of only three colours was chosen – Winsor blue, alizarin crimson and Indian yellow.

1 Having lightly drawn the main shapes in with a soft pencil, a large flat brush was used to establish the middle values, for which a mix of Winsor blue and alizarin crimson was used.

2 Winsor blue and a no. 16 round brush was used to paint in a fairly strong dark blue sky area. This immediately produced a strong value contrast that made the light building stand out.

3 All the greens were then added, using mixes of Winsor blue, Indian yellow and a little alizarin crimson to make a middle value green for the vines on the central building.

4 Indian yellow and alizarin crimson were mixed to paint the door and windows and to generally add a little warm colouring to the painting.

5 The darkest shadows and details were added with a mix of Winsor blue and alizarin crimson.

6 Finally, a stiff brush was used to spatter texture on in the foreground, and a knife used to scratch out a few small highlights.

Key Planning Points

- To produce unity, choose a limited range of colours
- Do not be afraid to use rich dark mixes; these will make the light areas appear much brighter
- Try using a large flat brush for the early stages of a painting

Painting Pattern

When you are planning a picture it is important to create a well-organised design that will hold the viewer's interest. One way to achieve this is by introducing repeated shapes, patterns and colours into your composition. Elements that repeat and echo each other help to unify the picture, and at the same time create lively rhythms that entertain the eye.

W E HUMANS ARE patterns, in the same way that we respond to the regular, rhythmical beat of music or poetry. There are many subjects in nature that offer shapes and patterns which can be used to create interesting designs within your paintings. Look out for the subtly varied rhythms and patterns formed by flowers and foliage, clouds, waves, trees, fields and mountains, and how these are often echoed by their own shadows or reflections. In contrast, man-made constructions contain bolder, more regular patterns such as those formed by windows, doors and roofs, fence posts, stone walls, and so on.

Still-life subjects lend themselves especially well to the exploration of pattern. Objects of similar shape, such as fruits and vegetables, or jugs and bowls, can be grouped together to form a unifying pattern. Decoratively patterned fabrics, rugs or china can be incorporated into the set-up. Remember that colours and values, too, can be repeated and contrasted to form satisfying visual patterns that help to lead the eye moving around the picture.

There are many ways in which you can use patterns in your compositions, but beware of making them too regular and monotonous. A rhythmical flow of similar shapes, each one subtly different from the other and not too regularly spaced, adds spice to a design.

If pattern interests you, do remember two important aspects of composition: balance and contrast. Try to include solid, quiet areas in your picture to offset the busy, active, patterned ones.

The 'patchwork quilt' effect of fields stretching into the distance has a universal appeal.

Flowers and leaves have graceful forms that repeat and echo each other.

Patterns of light and shadow can be fascinating in themselves. Think about the dappled shadows cast by trees onto the woodland floor beneath, or the fleeting shadows of clouds scudding across the hills.

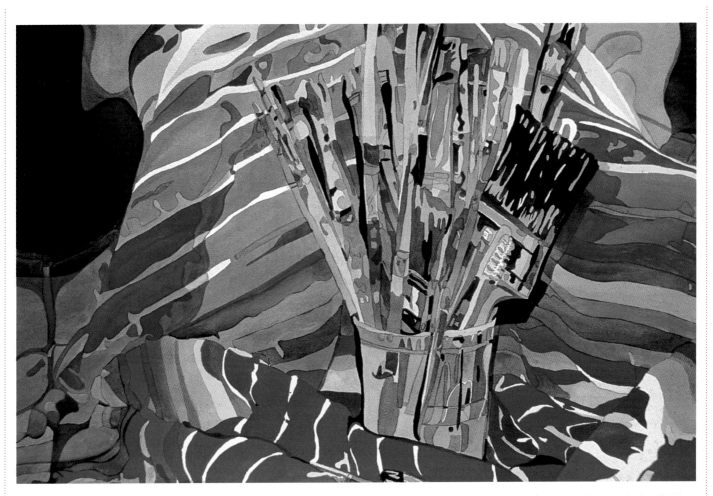

BRUSH BOUQUET
SANDRA A. BEEBE

This painting is a fine example of the use of overall pattern. Colour has been used to give interest, contrasting cool blues with hot reds. Smaller areas of the same combination are echoed throughout, offset by neutral greys and browns. Black and white have also been incorporated to produce a complete range of tonal values.

 The striped fabric has been cleverly arranged horizontally so as to contrast with the vertical shapes of the brushes in the pot. A strong side light was positioned to produce clean, sharp edges and just enough shadow to suggest a hint of depth behind the brushes. The approach here is very controlled and each small area was carefully drawn before the watercolour washes were applied with precision. The theme of pattern was always very much in the artist's mind; she has deliberately sought a graphic effect of flat colour shapes rather than a more naturalistic grading of colour and tone.

This enlarged detail shows the rich pattern of small intricate colour shapes, all carefully considered for contrast, balance and design.

Using Intense Colour

IN THIS DELIGHTFUL still-life, the gaily checked cloth is not merely a 'background' element but a major feature, providing both contrast and harmony. The geometric pattern contrasts with the organic forms of the flowers, but creates a colour harmony by echoing their rich reds. So much pattern and colour could be overwhelming, but the area of white paper serves as a resting place for the eye.

Materials

Sheet of 410gsm (200lb) cold-pressed watercolour paper • Watercolours: cadmium red deep, cobalt blue, ivory black, Hooker's green, cobalt green, cadmium yellow, burnt sienna, alizarin crimson • Brush: no. 4 round

Tonal Sketch

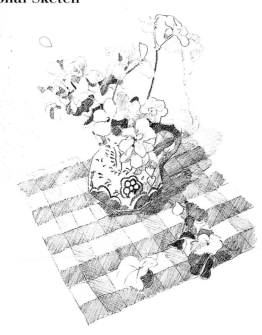

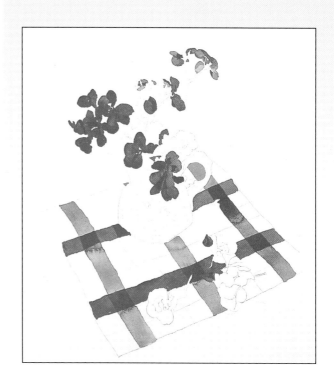

Pick out the reds

Lightly draw the main outlines of the composition in pencil. Using the no. 4 round brush, begin by painting the red geraniums and the red checks on the cloth. Try to match the tonal values correctly, allowing for the colour drying lighter than it appears when wet.

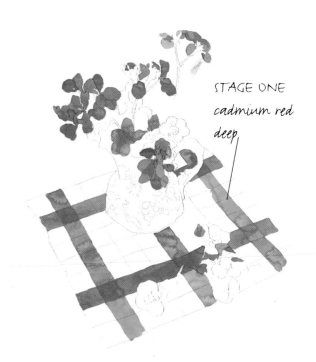

STAGE ONE
cadmium red deep

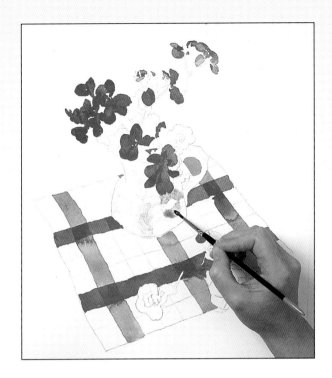

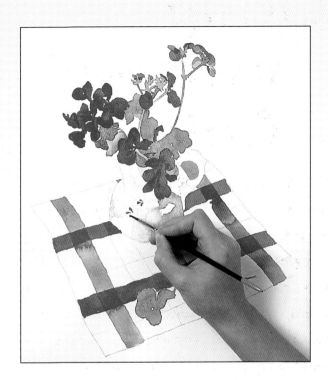

Shadow tones

Mix a middle-value wash of blueish grey and dilute it to a pale tint. Use this to paint the shadow side of the jug. Try to vary the tone of the wash rather than using a single tone as this makes the shadow appear 'pasted on'.

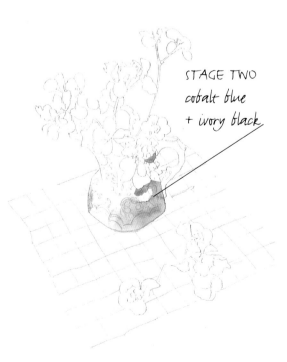

STAGE TWO
cobalt blue
+ ivory black

Paint the leaves

Mix a bright, leafy green using the colours listed below and paint the geranium leaves. You could try lifting out some of the colour here and there, using a squeezed-out brush or a crumpled tissue, to vary the tones and suggest the play of light on the leaves. Use the tip of the brush to suggest the pattern of leaves on the jug.

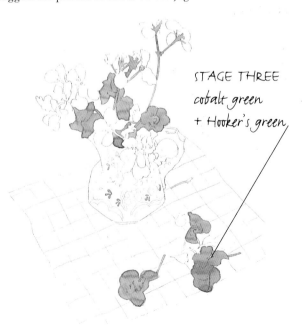

STAGE THREE
cobalt green
+ Hooker's green

Continue the cloth

Mix together the red and yellow suggested below to make a warm orange and carefully paint in the orange stripes on the cloth. Again, let the colour settle of its own accord to create shifting tones, which looks more natural than flat blocks of colour. Use the same colour for the flower motif on the lip of the jug.

Continue the jug

Once the orange washes have dried, mix a rich, dark blue and block in all the blue sections on the jug.

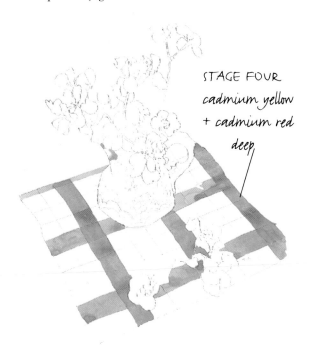

STAGE FOUR
cadmium yellow
+ cadmium red
deep

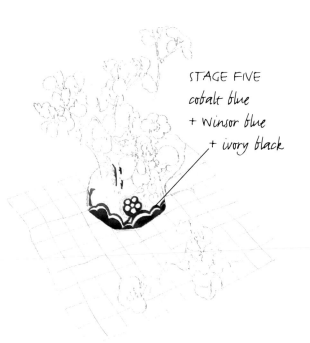

STAGE FIVE
cobalt blue
+ Winsor blue
+ ivory black

Introduce shadow tones

Mix a dark shade of green and use this to paint the shadow tones on the leaves and stalks of the geraniums. Add more blue to the mixture for the deepest shadows. Then paint the edge of the jug handle using the dark green mixture used in the previous step.

Complete the jug

While the previous washes are drying, mix together the colours listed below to produce a warm, reddish brown. Complete the jug by carefully painting the brown parts of the decorative pattern.

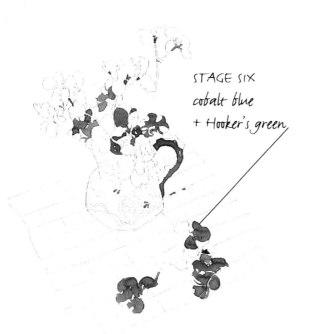

STAGE SIX
cobalt blue
+ Hooker's green

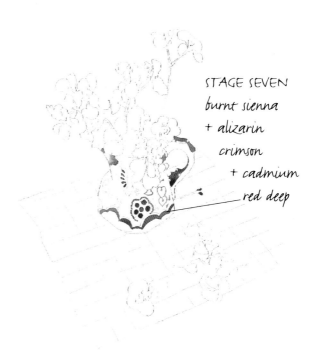

STAGE SEVEN
burnt sienna
+ alizarin
crimson
+ cadmium
red deep

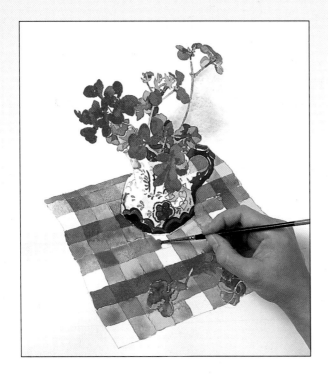

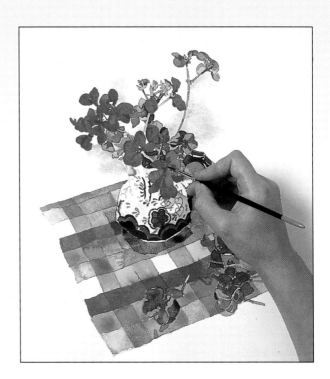

Complete the cloth

Mix a transparent wash of turquoise blue and paint in the remaining stripes and checks over the earlier reds and yellows. Dampen the area immediately behind the flowers, then brush some of the same blue onto the damp paper, allowing the colour to spread and diffuse naturally.

Add cast shadows

Allow the previous washes to dry, then mix blue with a spot of black to produce a delicate blue-grey and touch in some delicate shadows on the geraniums. Then indicate the shadows cast onto the cloth by the jug and the geranium leaves.

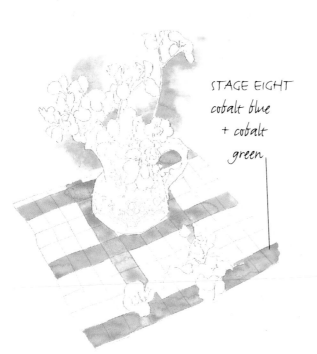

STAGE EIGHT
cobalt blue
+ cobalt
green

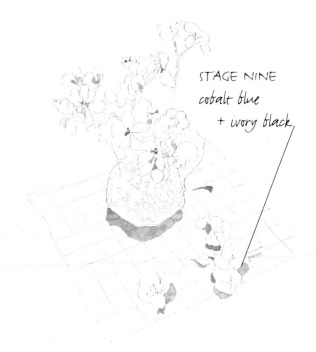

STAGE NINE
cobalt blue
+ ivory black

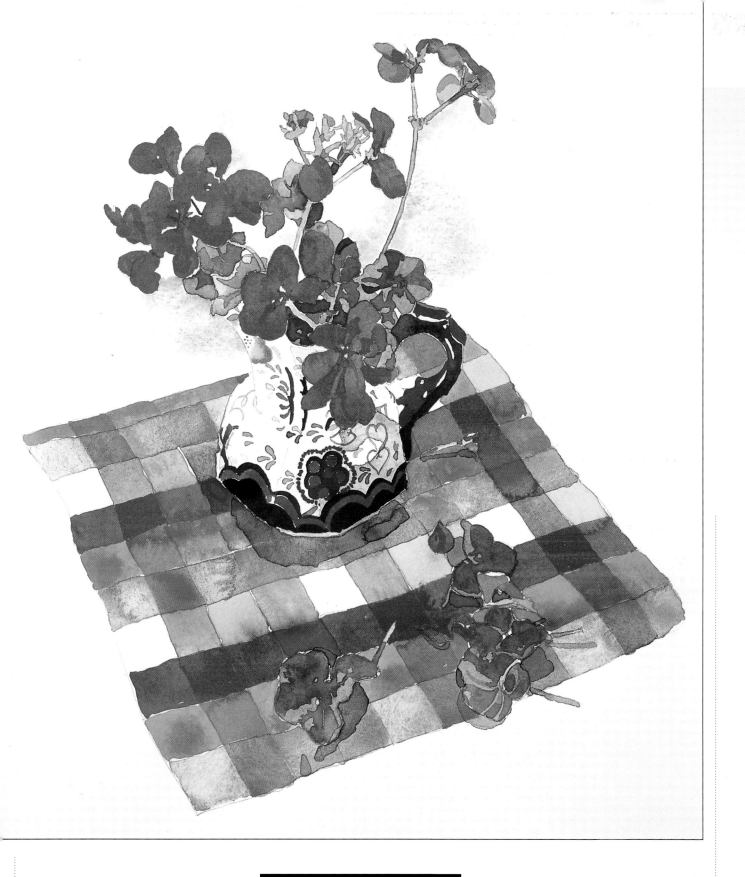

NICOLA GREGORY

The subject of pattern in painting is worth
exploring further. Try to create simple,
balanced compositions and keep to a limited
palette of colours, as in this painting, so as
to produce a unified image.

Exploiting Contrasts

THIS SUNNY GARDEN scene expresses the artist's delight in colour and pattern. Although the composition has a refreshingly spontaneous air, it has been deliberately planned so as to exploit contrasts of colour, pattern, organic and geometric shape, and light and shadow.

The success of this painting relies on accurate drawing and a considered approach, with a preliminary tonal sketch providing all the information the artist needed. Fairly small brushes were used so that the painted marks could be carefully controlled.

Materials

Sheet of 410gsm (200lb) cold-pressed watercolour paper • Watercolours: neutral tint, burnt sienna, permanent rose, aureolin, sap green, cobalt green, cobalt blue • Brushes: nos. 1, 3 and 6 round

Tonal Sketch

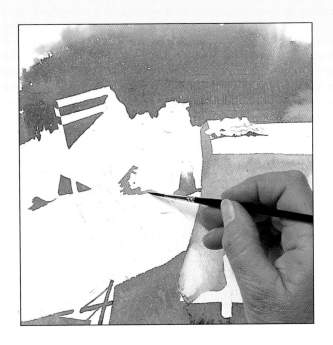

Paint the shadows

Lightly draw the main outlines of the composition in pencil. Mix up a wash of neutral tint and start by blocking in the shadow areas. Strengthen the wash for the darker shadows. Use the no. 6 brush for the large areas and the no. 1 brush for the smaller shadows and intricate shapes. Leave the painting to dry.

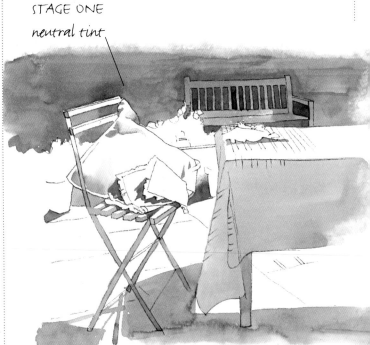

STAGE ONE
neutral tint

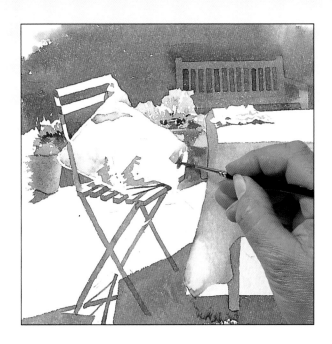

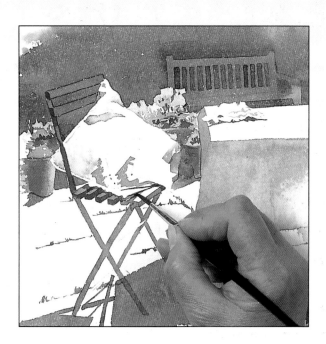

Flowers and foliage

Now you can start to build up the colours and patterns, starting with the tubs of flowers in the background. Work with the no. 1 and no. 3 brushes and the colours listed below. Keep these shapes very simple as they are in the background.

Paint the chair

Now paint the green chair using the tip of the no. 3 brush. When the first wash is dry, deepen the colour by adding a little earth colour and go over the shadowed parts of the chair. You will need a steady hand for this!

STAGE TWO
permanent rose

cobalt blue
+ aureolin

burnt sienna

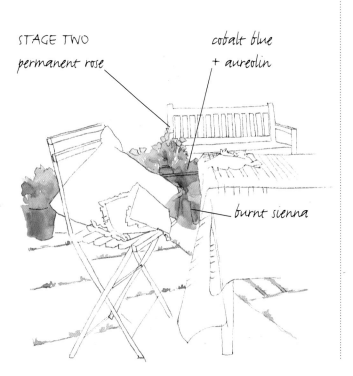

STAGE THREE
sap green
+ burnt sienna

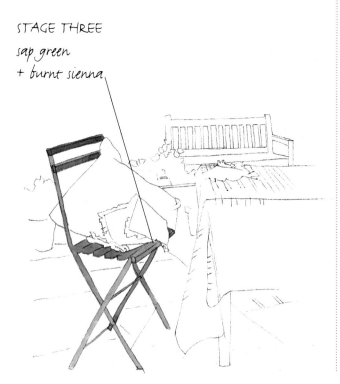

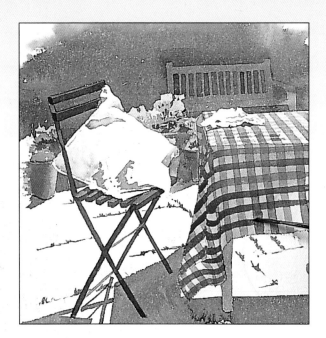

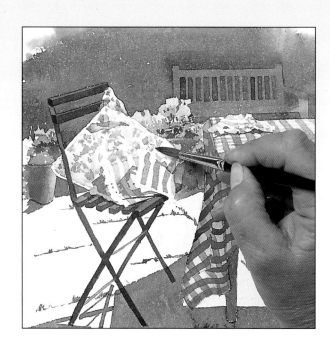

The tablecloth

Mix a middle-value wash of cobalt blue and carefully
paint the checked pattern on the tablecloth. The artist
used a rigger brush for this stage (if you don't have one,
an ordinary paintbrush will do just as well). A rigger has
long, flexible hairs and is ideal for line work and fine
details. The brush is pulled along so that the long hairs
follow the line, leaving a straight, clean edge.

STAGE FOUR
cobalt blue

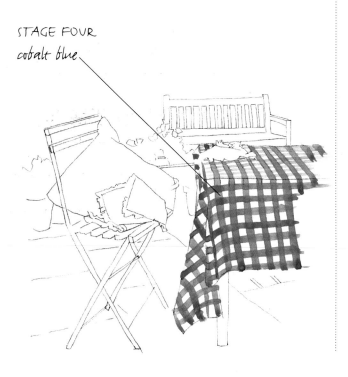

Add more pattern

Using the no. 6 brush and the colours listed below, paint
the striped cloths and patterned cushion next. Make sure
the lines of the stripes follow the folds and contours of the
cloths. Dilute the colours so that they are delicate and not
too strong.

STAGE FIVE
permanent rose
cobalt blue
cobalt green

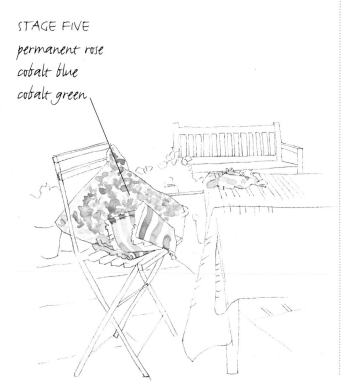

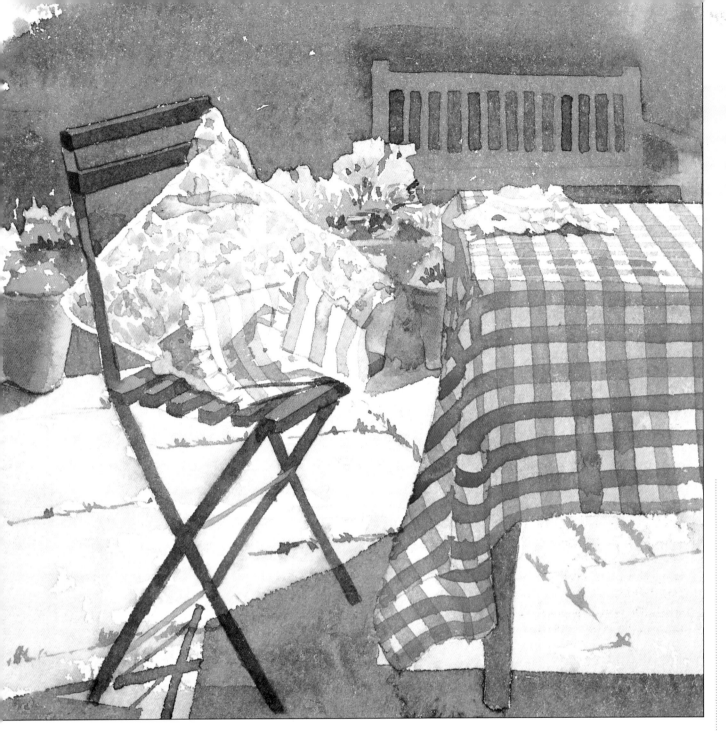

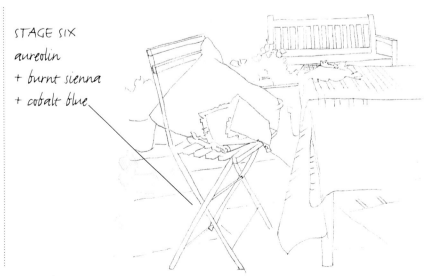

STAGE SIX
aureolin
+ burnt sienna
+ cobalt blue

*Finally, mix a greenish yellow (see left)
and loosely wash this over the patio floor to
help accentuate the impression of bright
sunshine in this attractive scene. Note how,
in the finished painting, the cool shadows
make the sunshine sparkle.*

Painting Pattern

BOTH OF THESE artists use patterns to create interesting compositions, though in contrasting ways. 'Yesterday's Antiques' has an almost abstract quality, with horizontal shapes interweaving and interlocking throughout the picture. 'Patricia' is more concerned with atmosphere and the effects of light, although pattern is a strong element, with the elegant, dark curves of the figure contrasting with the intricate background.

The solidity of the figure has a stabilising effect, anchoring the patterned background in space.

Working order

The foundation of the design was a single-line contour drawing. The interior of each object was developed with a variety of horizontal shapes. The drawing was transferred to the working surface (Arches 300gsm (140lb) cold-pressed paper) using a sheet of graphite paper. A colour scheme of cadmium orange, Winsor green and Winsor violet was chosen, with orange the dominant colour.

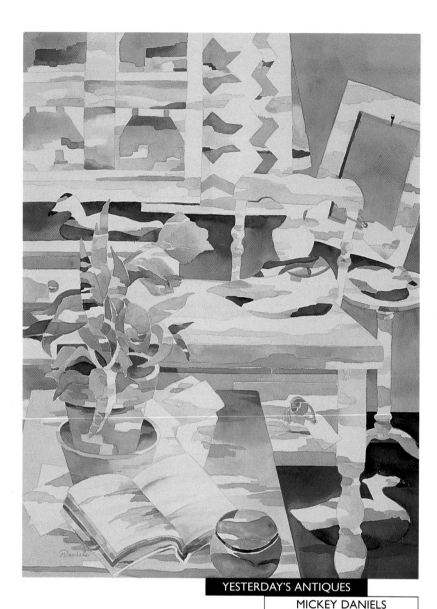

YESTERDAY'S ANTIQUES

MICKEY DANIELS

1 Each drawn shape was carefully dampened with water, and colours floated in, giving definition to the negative shapes. The white areas were left untouched.

2 The tulips were painted by dropping with a combination of yellow and red into orange, as were the quilt and background area. To strengthen the values, red, green and/or purple were used.

3 The leaves, round bowl and portions of the quilt were treated as an independent theme of green, varied by mixing it with yellow, red or purple.

4 The ducks were painted with shades of purple, adding red or green for interest.

Key Planning Points

- Careful planning was required to establish a balance of negative and positive shapes and white areas
- By making a drawing the same size as the painting, the whole composition can be worked out in advance
- Painting pattern requires careful brushwork; damping selectively keeps the paint within the boundaries of each shape

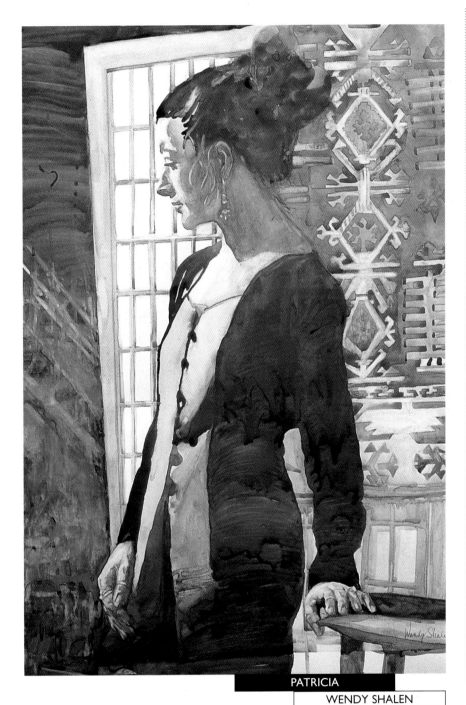

PATRICIA

WENDY SHALEN

Working order

The artist photographed the model, and to discern the tonal values, a xerox black and white copy was taken. An enlarged outline drawing was produced on a full sheet of Strathmore 4-ply Plate Bristol paper. The artist chose a limited palette of one yellow (raw sienna), one red (alizarin crimson) and two blues (cerulean and ultramarine). These colours were repeated throughout the painting.

1 The light areas on the screen and on the model's face and neck were initially left as white paper, and later washed over with pale raw sienna.

2 A mix of alizarin crimson and raw sienna was used for the facial mid-tones, and a touch of cerulean blue was added to these colours for the neck area. For the hair, ultramarine, alizarin crimson and raw sienna were mixed.

3 The pattern on the rug was painted with pure but diluted alizarin crimson and raw sienna, with a mixture of the two in some areas.

4 Raw sienna, more heavily diluted, was again used for the front of the dress, and a mixture of this and alizarin crimson for the hands and table top. All the dark areas, including the background on the left, were achieved with strong mixtures of ultramarine and alizarin crimson.

5 Diagonal light lines on the background were lifted out while the paint was wet, after which cerulean was laid over washes of raw sienna to simplify the area.

Key Planning Points

• The balance of light and dark values was planned well in advance of painting
• During work, the artist checked the composition by using a mirror to reverse the image
• The choice of a limited palette ensures compositional unity

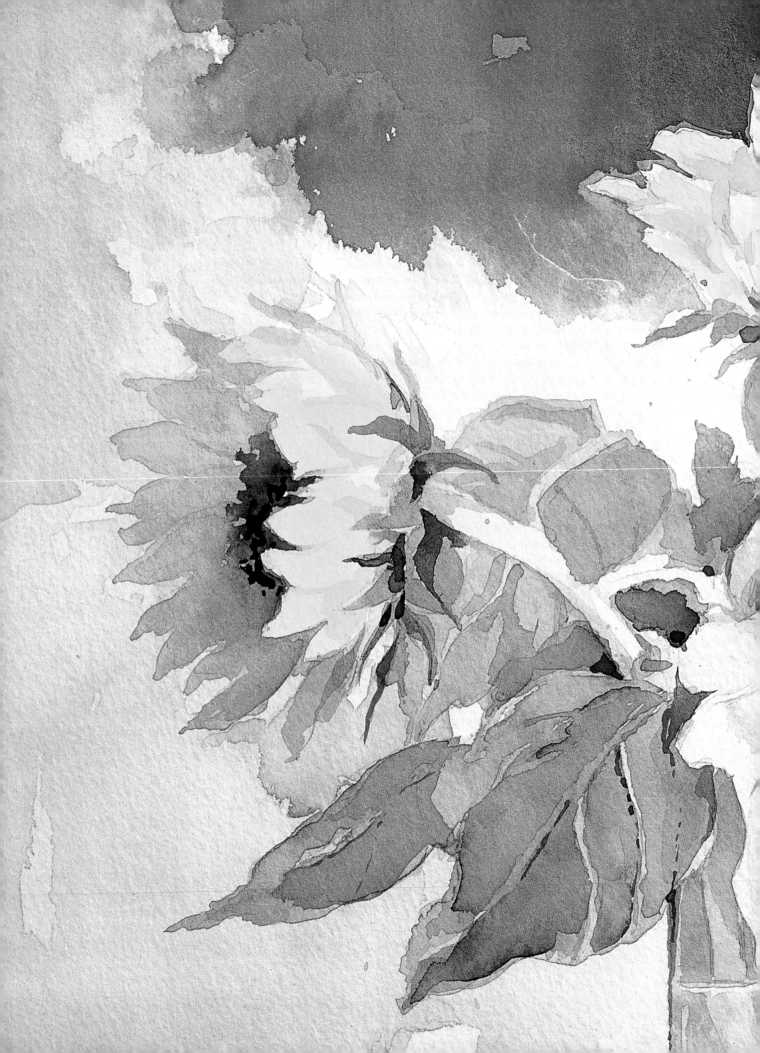

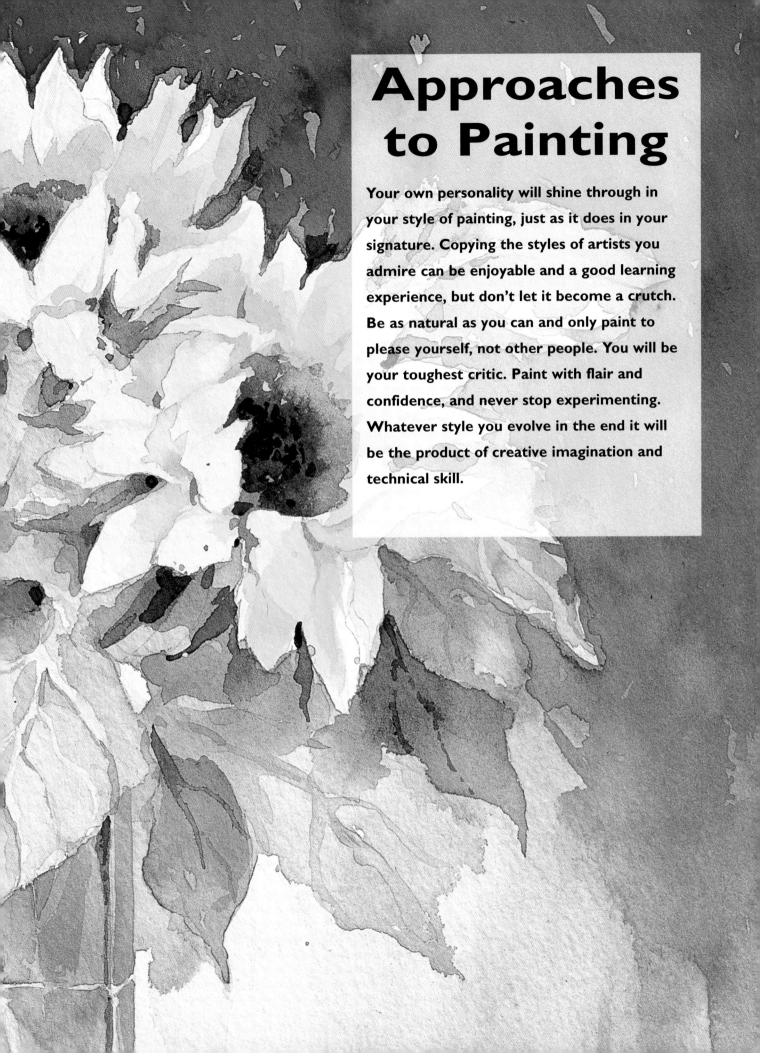

Approaches to Painting

Your own personality will shine through in your style of painting, just as it does in your signature. Copying the styles of artists you admire can be enjoyable and a good learning experience, but don't let it become a crutch. Be as natural as you can and only paint to please yourself, not other people. You will be your toughest critic. Paint with flair and confidence, and never stop experimenting. Whatever style you evolve in the end it will be the product of creative imagination and technical skill.

Developing a Style

Style in painting is often described as a distinctive manner of artistic expression. It cannot be consciously created or hurried along; it has to evolve naturally over time, just as one's handwriting does. As your drawing and painting skills develop, your own unique artistic style will begin to evolve and be recognisable to others. When that happens you will feel you are at last beginning to achieve something.

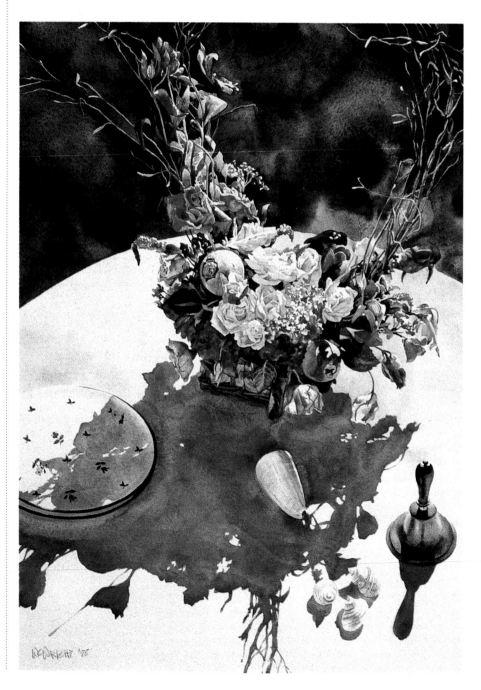

BASKET BOUQUET
WILLIAM C. WRIGHT

To make this painting sing with bright light, the artist has not been afraid to use very dark colours against almost white paper. The dark shadow shape has been skilfully used to produce an intriguing and well-balanced composition.

The use of reflected light adds interest to what could otherwise have been a black 'hole' in the composition.

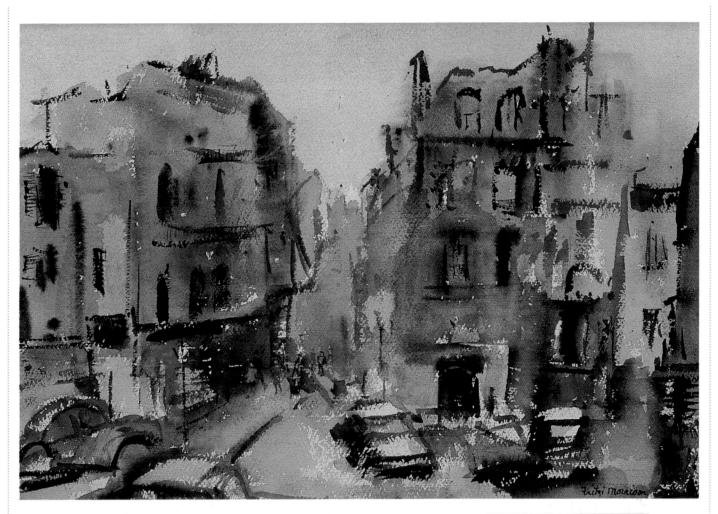

accidental
softening of lines

small touches of
red add zest

rich darks used for
contrast and
atmosphere

THE LEFT BANK, PARIS
FRITZ M. MORRISON

*The energy of a Parisian street has been
captured deftly and accurately here through
a combination of loose washes and linear
marks, and the rough-surfaced paper adds
to the excitement by breaking up the
colours. Happy accidents have occurred
where wet washes have been applied over
still slightly damp lines. A limited colour
range gives the painting unity, while
small touches of bright colour add a note
of interest.*

THE TOOL WE use for painting will obviously have an influence on the style of our pictures. One artist may find that working with large brushes and rough paper in a loose, impressionistic manner suits his way of expressing himself. Another artist may prefer to work in a more detailed, precise manner using small brushes and smooth paper.

Artistic style, however, is not simply a matter of tools and technique, it is also about a particular way of seeing. An artist creates a painting not only by putting together a particular set of marks but also by choosing and composing the subject and then by manipulating both colours and tonal values so as to underline the message he or she wishes to convey. Of course, as

a beginner your attention will focus initially on how to make a tree look like a tree, or an apple like an apple. However, once you have mastered the basics of perspective, composition and different painting techniques, you can begin to concentrate on interpreting — rather than merely copying — your subject matter. Your personal way of interpreting what you see is a vital aspect of painting and should not be underestimated.

An important step in developing your own style is to look at the work of

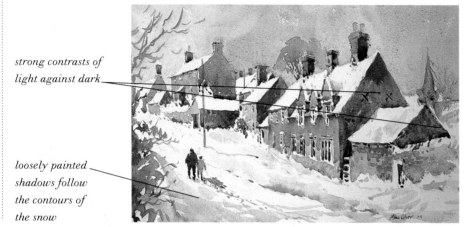

strong contrasts of light against dark

loosely painted shadows follow the contours of the snow

FIRST SNOW
ALAN OLIVER

This painting is about contrasts: of lights against darks, cool greys against warm browns, and juicy wet washes against crisp-edged brushstrokes. A limited palette of three colours — French ultramarine, burnt sienna and raw sienna — was used throughout, and this helps to give unity to the painting. The figures have been added to form a focal point and to give a sense of scale to the picture.

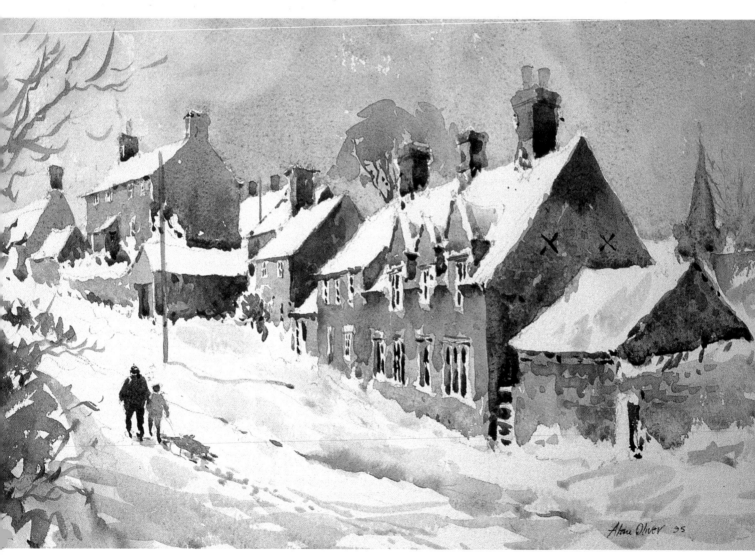

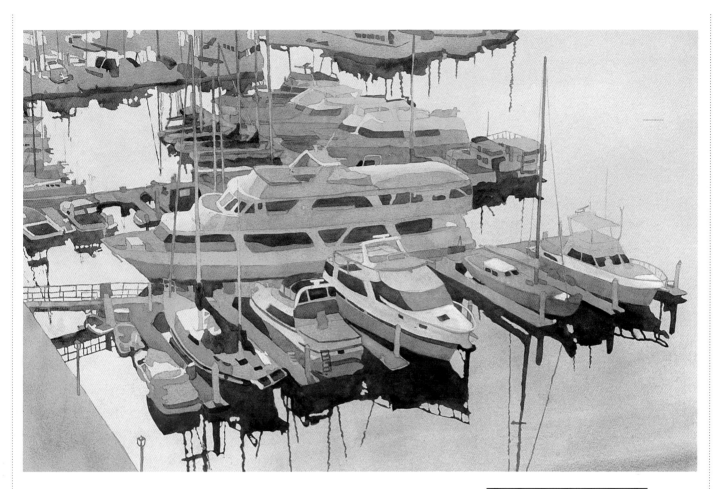

the strong vertical of this mast conforms to the rule of thirds and is an important element of the design

the rich dark shadows contrast with the warm colours of the boats

HARBOUR DAWN
KAREN MATHIS

Precise drawing and clean, sharp-edged washes are a feature of this artist's work. Here is a marvellous example of diversity within unity: the echoing shapes of the boats make up a lively pattern of light and dark, while the limited colour range lends unity to the whole.

artists whom you admire. Almost every great artist has been influenced by another artist before him, and you will inevitably be drawn to the work of a particular painter because it touches something deep inside you. The influence of that painter may unconsciously begin to appear in your own work, but eventually something of yourself will come to the fore. I urge you to study the work of that great English water-colourist, J. M. W. Turner (1775–1851).

Here was a man with a style all his own. He was not afraid of creating 'accidents' on the paper and then manipulating them to create wonderful atmospheric effects. Many of his paintings were produced by flooding the paper with paint and then washing off the excess to leave delicate stains of colour which he glazed one over the other, like sheets of tissue paper. Of course, there will be days when you feel you are getting nowhere and you are

dissatisfied with the work you are producing. All artists have these feelings from time to time, and it is always a good excuse to try something new. Experimentation is important; an artist should be moving forward constantly, developing new ideas, new ways of using paints and materials, new ways of thinking. Try tackling new subjects, changing your usual palette of colours, or using bigger brushes. Throw caution to the wind and slosh some big, wet, juicy washes onto wet paper. Try scraping into a wet wash, or spattering paint on with an old toothbrush. Some experiments may mean wasting some paper, but it will be well worth it.

In the end, the best advice I can give is to paint and paint and paint. As your skills develop you will begin to paint with fluency and confidence, and your own work will bear your own unique stamp.

AFTER THE CONCERT
BERENYCE ALPERT WINICK

The wet into wet technique is used to stunning effect here in capturing the atmosphere of a winter evening in the city. An almost monochromatic colour scheme and minimal detail heighten the mood.

repeated shapes bring movement and rhythm to the composition

opaque white spattered on at the dry stage to suggest falling snow

ANNA'S BEDROOM
JOHN LIDZEY

The main preoccupation of this painter is the study of light. Here, attention is focused upward towards the mirror through the contrast of light against dark. The low-key colours and fluid, loose technique combine to create an intimate mood.

rich darks against bright lights

drips of water allowed to run down the dry painting to add textural interest

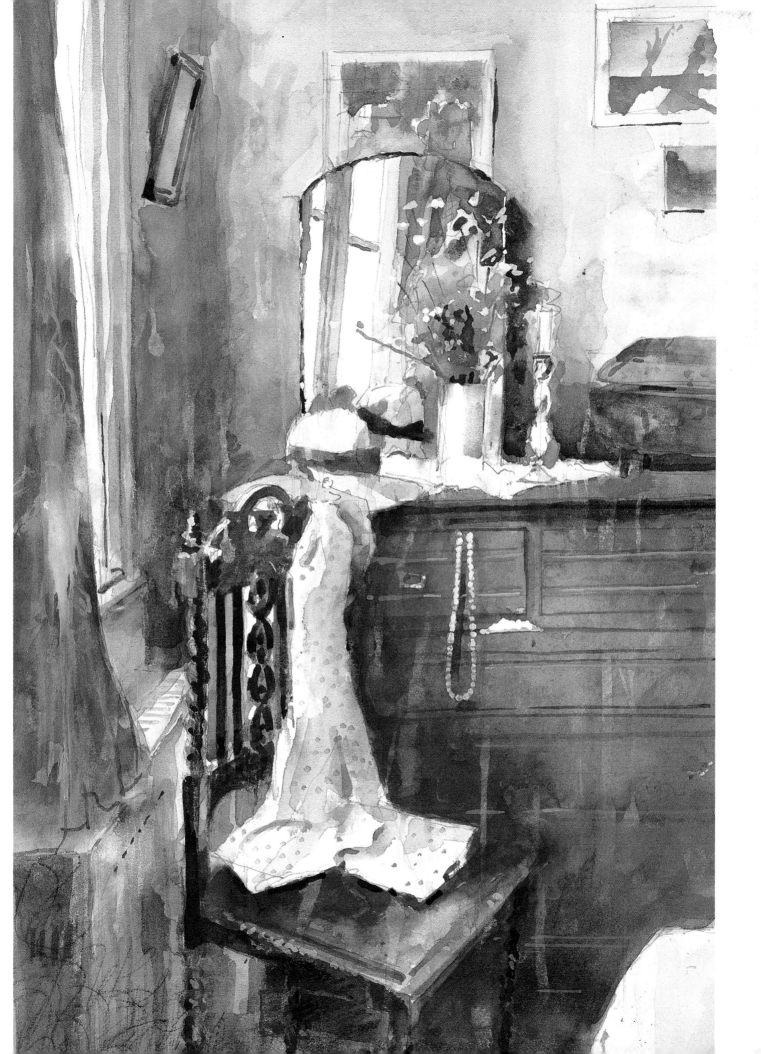

Two Artists, One Scene

IT IS INTRIGUING to see how two artists, faced with the same subject, will interpret it in quite different ways. The sequence of illustrations which follows shows you the development of two paintings – one by John Lidzey and one by Alan Oliver. Both were asked to produce a watercolour painting of the same scene of an Italian lake (see below). The sequences in the development of the paintings are shown side by side, so that you can compare and contrast them for yourself. The subject is identical in both, and the compositions are very similar, yet the impression conveyed by each painting is quite different.

Both artists began by making thumbnail sketches and tonal studies to test out their compositional ideas and get to know the subject better. Their independent concepts began to evolve in the paintings, with the first artist using a direct, wet-on-dry method and the second artist using the wet-in-wet method. The contrast in atmosphere and mood between the two paintings is also quite distinct.

The Scene

Thumbnail sketches

John Lidzey begins by exploring the compositional possibilities of the subject. In sketch **1** he concentrates on the attractive grouping of the trees. In sketch **2** he tests the idea of placing the trees on the right of the composition. In sketch **3** he places the trees on the left and crops them off at the top in order to make a more horizontal composition.

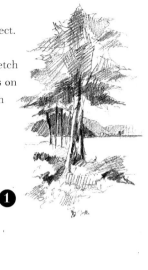

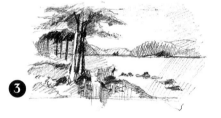

Thumbnail sketches

Alan Oliver also uses thumbnail sketches to help him decide on a suitable composition – which need not necessarily be exactly as in the reference photograph. In sketch **1** he adds more foliage on the right in order to balance the trees on the left. In sketch **2** he crops the image to create a more vertical format. In sketch **3** he increases the foreground area by raising the horizon level.

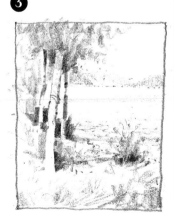

Tonal study

The artist now produces
a bigger sketch which
analyses the
compositional structure
in more detail. He uses
charcoal, indicating the
light and dark areas of
the image by smudging
the charcoal marks with
his fingers in the darkest
areas. This tonal study
will form the basis of the
finished painting.

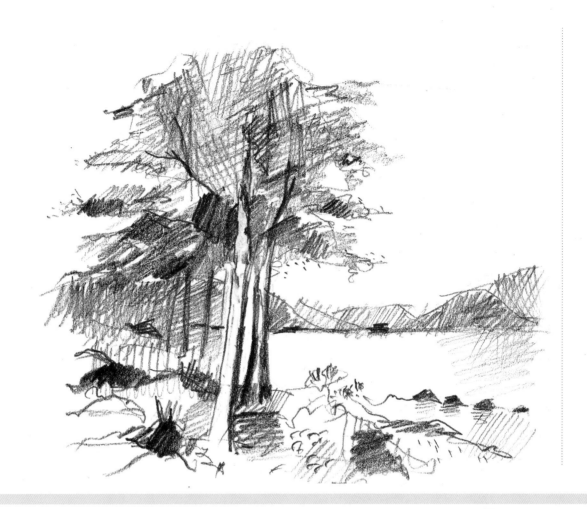

Tonal study

Having rejected the idea
of a vertical composition,
the artist makes a more
detailed tonal study
based on his first
thumbnail sketch. He
likes to use a short,
stubby pencil (a soft
grade such as 3B) for this
as he finds it allows his
hand greater freedom
than a long pencil for
producing fluid marks.

The reference photo
may well be put away at
this stage and not looked
at again. The preliminary
sketches have helped the
artist to simplify the
subject and they provide
all the information he
needs as to atmosphere,
colour and tonal values.

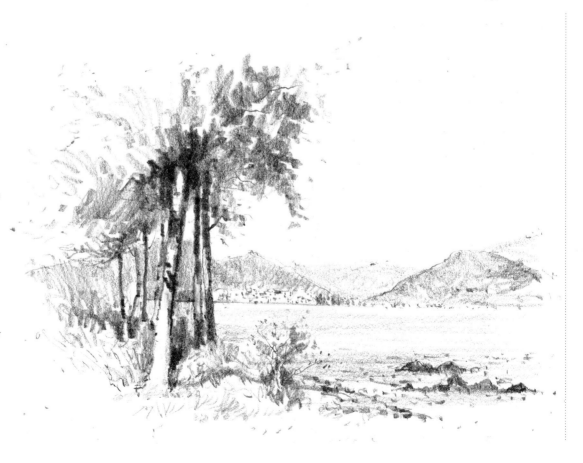

Tools and colours

Each artist develops a liking for different colours and tools, and no two artists work in the same way. We all see things differently, and it is the artistic imagination which produces individual images.

This artist, John Lidzey, uses a colour scheme that will produce strong darks. The inclusion of indigo, a rich blue-black, gives the dark greys and strong contrasts. The addition of opaque white enables the artist to produce sparkles of light in the final stages of a painting. He works on a 'not pressed' 300gsm (140lb) paper, stretched over a backing board, and used two brushes, nos. 2 and 9, a dip pen, a 2B pencil and a stick of charcoal.

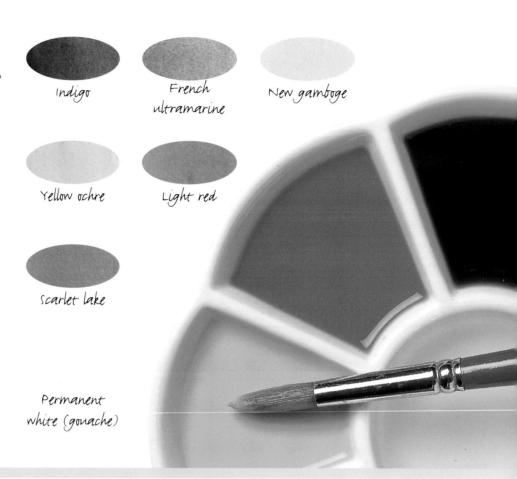

Indigo

French ultramarine

New gamboge

Yellow ochre

Light red

scarlet lake

Permanent white (gouache)

Tools and colours

A similar colour scheme is used by Alan Oliver for this picture, but without the strong contrasts of indigo and white. The colours used still give a tremendous range of tones when mixed, and the artist has made use of masking fluid to reserve highlights and keep a luminous quality in the picture. All the colours used are transparent watercolours, except the light red, which is used with the ultramarine to produce soft greys.

The paper used is 'not pressed' 300gsm (140lb) stretched over a backing board. In addition to the masking fluid, the artist uses a 4B pencil, nos. 2 and 14 brushes, a 16mm (1in) flat brush and a Chinese no. 12 round brush.

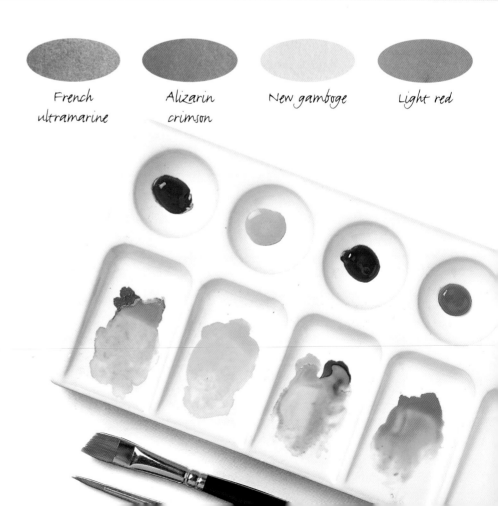

French ultramarine

Alizarin crimson

New gamboge

Light red

Outline drawing

Having stretched his watercolour paper, the artist begins by lightly drawing the main elements of the composition with a 2B pencil.

Setting the atmosphere

Working on dry paper, the artist brushes a pale wash of French ultramarine over the upper sky area, fading down to an equally pale wash of yellow ochre near the horizon. The same colours are washed over the lake. Then a stronger tint of yellow ochre, together with scarlet lake, is brushed over the foreground.

Outline drawing

Using a series of light, staccato pencil marks, the artist establishes the main outlines of the composition.

Masking the lights

Whereas the first artist normally paints around the light areas, the second artist prefers to stop them out with masking fluid as this offers him greater freedom to apply his wet-in-wet washes. He uses an old brush to apply the fluid to the white buildings in the distance and the light-struck sides of the tree trunks.

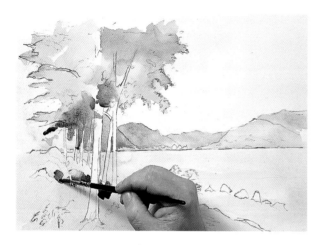

Background and foreground

A smaller brush is used by the artist to paint the distant mountains with thin washes of indigo and scarlet lake. The tree canopy is painted wet into wet, using new gamboge for the lighter foliage and a mixture of new gamboge and indigo for the darker foliage. Darkening the mix with more indigo, the artist suggests some of the rocks in the foreground.

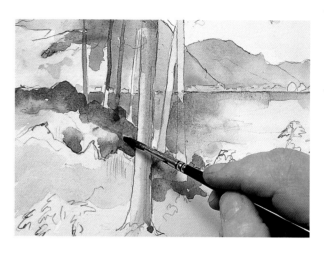

Mid tones

Deeper washes of French ultramarine are used to suggest the reflections of the mountains in the lake. The tree trunks are painted with different mixtures of yellow ochre, new gamboge and indigo. Then the rocky foreground is suggested with further washes, overlaid wet on dry. A mixture of indigo and yellow ochre is used for the dark line of rocks.

Setting the atmosphere

While the masking fluid dries the artist mixes a wash of French ultramarine and a wash of alizarin crimson. He floods the paper with clean water and then works over the sky, mountains and lake with variegated washes of blue and red, letting them settle wet in wet on the damp paper. This underwash sets the overall tonality of the scene.

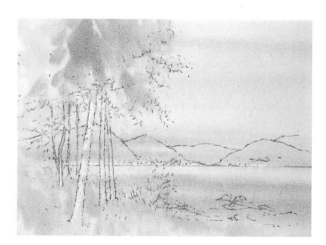

Foreground work

The trees and foreground are now established with washes of new gamboge for the lights, and new gamboge mixed with French ultramarine for the darker tones. Again the colours are allowed to spread and mix on the damp paper.

Lifting out colour

The artist uses a piece of crumpled tissue to gently lift out the wet colour at the base of the rocks. This creates a soft edge which blends naturally into the surrounding grassy area. It is this 'lost and found' quality of edges that lends atmosphere to a watercolour painting.

Developing colours and forms

Further layers of indigo and scarlet lake are washed over the distant mountains, leaving the paler underlayer untouched in places, to suggest their craggy forms. The individual clumps of tree foliage are developed further with washes of new gamboge, yellow ochre and indigo. The painting is left to dry.

Middle distance

Having established the lightest values, the artist now works on the slightly darker values in the middle distance; the distant mountains are blocked in with a wash of French ultramarine deepened with alizarin crimson.

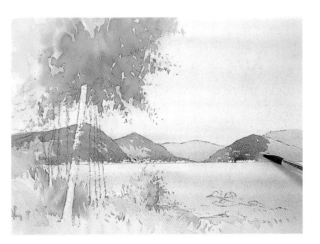

More mid tones

Now the greens in the foreground are developed further. The artist uses the same colours as previously for the foliage but this time at a stronger concentration. The mountains are more clearly defined with further washes of blue, leaving the light underwash uncovered in places.

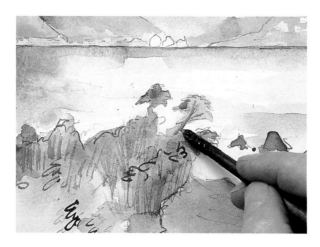

Adding linear detail

With a few sketchy marks the artist now introduces some linear detail in the foreground of the painting to suggest the scrubby foliage and grasses. For this he uses a dip pen and a strong mixture of indigo, scooping the colour onto the nib from a brush.

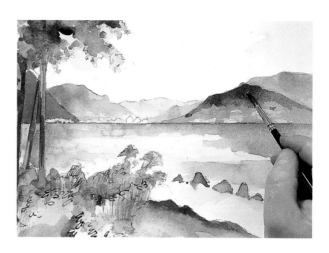

Receding space

Here you can see how the stronger detail in the foreground helps to bring it forward in the picture plane, creating the illusion of receding space. Now the nearest range of mountains is darkened with indigo; again, this brings them forward, with the further ranges becoming lighter in value as they recede in space.

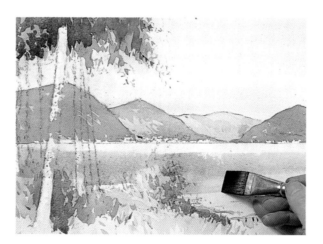

Creating recession

The artist now mixes French ultramarine with a touch of light red and washes this over the lake with a large flat brush, leaving a narrow band of lighter tone in the distance. The water in the foreground is darkened further by adding a touch of alizarin crimson to the mix. This gradation of values gives the illusion of the water receding into the distance.

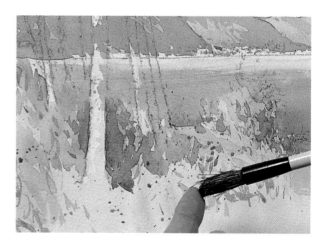

Spattering

Where the first artist used linear work to suggest foreground detail, the second artist is using a technique called spattering. He dips a Chinese brush (which has fairly stiff hairs) into a wash of light red and, holding it above the area to be spattered, quickly draws his fingernail through the brush hairs. This sends a light shower of paint droplets onto the paper.

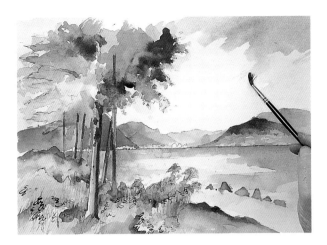

Painting the storm clouds

The dark storm clouds on the right are suggested with scrubby strokes of French ultramarine and yellow ochre, leaving a patch of light sky in the centre.

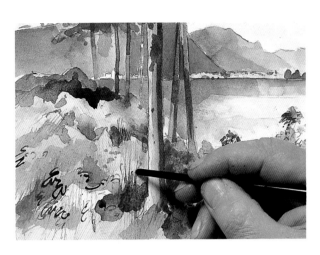

Developing the foreground

The artist decides that the immediate foreground requires strengthening with a little more tone and detail. Here, he has applied a dark wash of yellow ochre and indigo and is using the tip of the brush handle to tease out the wet paint into lines that suggest tall grasses.

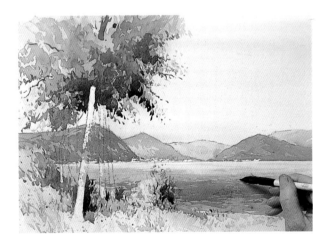

Adding movement

Individual clumps of foliage are now suggested using a dark, rich green made from French ultramarine and new gamboge. Then the colour of the foreground water is deepened with further washes of French ultramarine with light red. The fine point of the Chinese brush is excellent for making marks which can suggest both the movement of the leaves and also the surface of the water.

Background detail

The artist now removes all of the masking fluid by rubbing with his finger, revealing the pristine white paper beneath. The distant lakeside village is suggested with small touches of light red and French ultramarine, leaving flecks of white paper for the sunlit walls of the houses.

Enhancing atmosphere

Now the artist concentrates on mood and atmosphere. The rocks jutting out of the water are strengthened with a dark mix of indigo and scarlet lake. Yellow ochre and indigo are used to darken the overall tone of the trees. Then a further wash of blue is added to the upper sky, enhancing the effect of eerie light.

The final touches

Using a very small brush, the artist suggests the lakeside village glimpsed in the distance with tiny touches of light red and permanent white gouache paint.

The tree trunks

Strokes of French ultramarine and light red suggest the dappled shadows on the nearest tree, then the two colours are mixed to make a rich dark for the further trees.

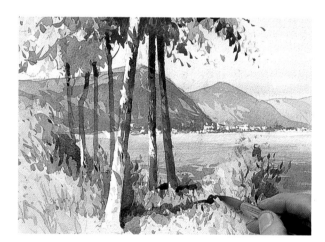

Cast shadows

Finally, a transparent wash of French ultramarine and alizarin crimson is mixed for the shadows cast by the trees. Shadows are surprisingly colourful, particularly on a sunny day.

The finished painting

The first artist's interpretation of the subject has produced a wonderfully atmospheric painting, evoking the threatening mood of an approaching storm. This has been achieved through the use of a subtle colour scheme and the skilful orchestration of dark tonal values.

JOHN LIDZEY

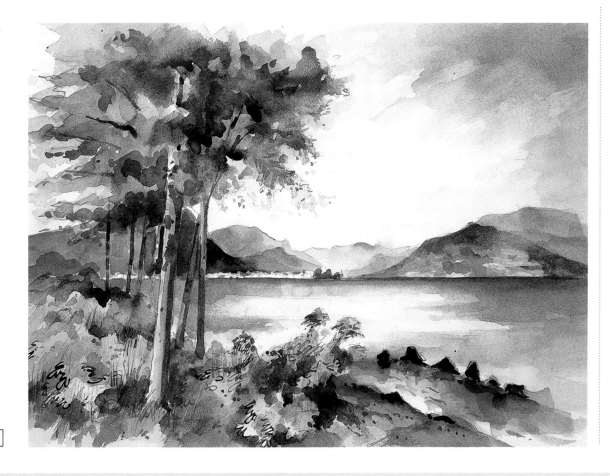

The finished painting

Although similar in composition to the first painting, the mood and atmosphere in the second painting are quite different. Light, fresh colours have been used to suggest the atmosphere of a bright, sunny day with a strong light coming from the left.

ALAN OLIVER

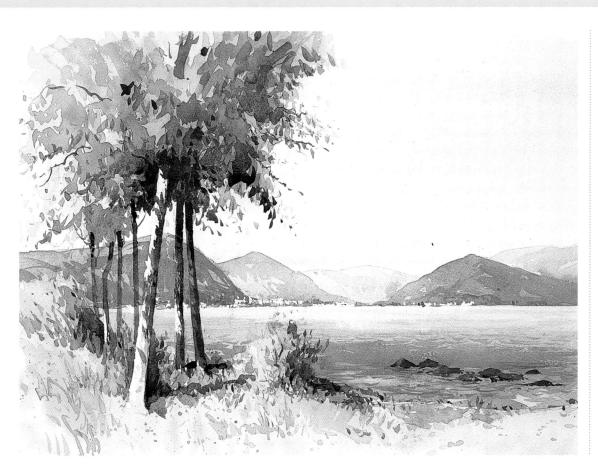

Index

Illustrations of complete pictures are indicated by *italics*. Where accompanied by a 'working order' commentary, '+*w*' is added to the reference. Working illustrations occur on every page and are not indexed separately. SSD = Step-by-Step Demonstration

Credits

Illustrations of complete pictures are credited on
the page, but we would particularly like to thank
the following for their help in demonstrating
step-by-step techniques for photography:
Adalene Fletcher, **Nicola Gregory**, **John Lidzey**,
Kay Ohsten, **Julia Rowntree**, **David Weston**
and especially the author, **Alan Oliver**.